MW01434908

RotoVision

[digital lab] 0.2

\> **DIGITAL LAB:**

**PRINT & ELECTRONIC DESIGN**
**ADVERTISING**
**WRITTEN AND DESIGNED BY MONO**

**A RotoVision Book**

**Published and distributed by RotoVision SA**
Rue du Bugnon 7
CH-1299 Crans-Près-Céligny
Switzerland

**RotoVision SA, Sales & Production Office**
Sheridan House, 112/116A Western Road
Hove, East Sussex BN3 1DD, UK

**T** +44 (0)1273 72 72 68
**F** +44 (0)1273 72 72 69
**E-mail** sales@rotovision.com
**www.rotovision.com**

**Copyright © RotoVision SA 2001**

All rights reserved. No part of this publication may be reproduced, stored in a retrieval system or transmitted in any form or by any means, electronic, mechanical, photocopying, recording or otherwise, without permission of the copyright holder.

The products, trademarks, logos and proprietary shapes used in this book are copyrighted or otherwise protected by legislation and cannot be reproduced without the permission of the holder of the rights.

10 9 8 7 6 5 4 3 2 1

ISBN 2-88046-557-5

**Book design by mono**
www.monosite.co.uk

**Production and separations in Singapore by**
ProVision Pte. Ltd.

**T** +65 334 7720
**F** +65 334 7721

# contents >

| Project | Information | Ref. |
|---|---|---|
| > 1 | britart.com<br>**Agency:** mother<br>UK | 10–19 |
| > 2 | Jimmy Grimble<br>**Agency:** Nicework<br>UK | 20–29 |
| > 3 | Buddy Lee<br>**Agency:** Fallon Minneapolis<br>USA | 30–47 |
| > 4 | Queercompany<br>**Agency:** Anti-Corp<br>UK | 48–55 |
| > 5 | DRD<br>**Agency:** Faydherbe/De Vringer<br>The Netherlands | 56–65 |
| > 6 | uboot.com<br>**Agency:** Magic Hat<br>UK | 66–81 |
| > 7 | Bioform<br>**Agency:** MBA<br>UK | 82–87 |

| Project | Information | Ref. |
|---|---|---|
| > 8 | 747 AM<br>**Agency:** KesselsKramer<br>The Netherlands | 88–99 |
| > 9 | Austereo<br>**Agency:** The Glue Society<br>Australia | 100–105 |
| > 10 | Playstation 2<br>**Agency:** tomato<br>UK | 106–115 |
| > 11 | Volkswagen<br>**Agency:** BHWG Proximity<br>UK | 116–127 |
| > 12 | CAT Denim<br>**Agency:** Magic Hat<br>UK | 128–137 |
| > 13 | Guinness<br>**Agency:** Abbott Mead Vickers • BBDO<br>UK | 138–147 |
| > 14 | Rizla<br>**Agency:** Cake<br>UK | 148–157 |

> 1 britart.com

> 2 Jimmy Grimble

> 3 Buddy Lee

> 4 Queercompany

> 5 DRD

> 6 uboot.com

> 7 Bioform

> 8 747 AM

> 9 Austereo

> 10 Playstation 2

> 11 Volkswagen

> 12 CAT Denim

> 13 Guinness

> 14 Rizla

# intro

It is a fact of modern life that advertising is becoming more and more pervasive. It is hard to think of a time in our everyday lives when we are not exposed to a commercial message. In our homes, in the street, on public transport, at work, or on the internet we are constantly bombarded with advertisements and are barely conscious of most of them. The proliferation of new media, new markets and new products has massively increased both the opportunity and the necessity to direct our attention towards consumer goods and services.

But the greater our exposure to advertising, the greater the need to develop distinctive advertising strategies to attract our attention, especially as society is becoming less receptive to the extravagant claims made on behalf of ordinary products and services. All advertisements must now strive to be eye-catching to have any chance of standing out from the crowd. There are simple, well-tried formulas for achieving this, of which the most obvious – literally – is to advertise on a vast scale, swamping whatever medium and location is being targeted with a single message. An alternative approach is to operate at a more subtle and subliminal level, a familiar tactic being the simple insertion of an easily recognised brand identity into an everyday object, where its actual status as advertising is disguised by its context, such as the logos on clothing or on sportswear.

However the goal of most ambitious advertising campaigns has always been to attain recognition through originality. The memorable message that will make an audience think and think again is the pinnacle of effective advertising. But as we are aware, in an image-saturated and media-literate society, the capacity of advertising to appear intelligent, witty or shocking has been radically diminished. Therefore, those successful strategies that have exploited words, images or communications technologies in new and surprising ways become more worthy of our attention.

Given the range of skill and talent that is assembled for the business of creating advertisements, including copywriting, photography, illustration, typography, photography, film-making and art direction, it is not surprising that advertising continues to produce some of the most original, inventive and controversial work of any creative profession. Furthermore, the manner in which the creation of advertisements links arts-based practices with such scientific disciplines as psychology and sociology, provides advertisers with a unique insight into the condition of contemporary society, and gives them a powerful role in shaping that society. Which of today's prevailing thoughts and attitudes will shape our opinions tomorrow? Which products will endure beyond the present and remain useful to our lives in the future? Advertising plays a crucial role in determining these outcomes.

**Digital Lab: Advertising** examines a range of distinctive advertising campaigns from around the globe, investigating and assessing their effectiveness in the communication of a message to a target audience. It provides a series of insights into the creative and technical processes of advertising, seen principally through the perspective of the creative director. And it investigates how advertising exploits the possibilities provided by the increasingly diverse channels of information and communication that constitute today's information society.

Digital Lab: Print & Electronic Design        advertising    britart.com

# project 0.1  britart.com

Nowhere is the urban landscape more dominated by advertising than on the busy city street. Posters selling us everything from holidays to household items jostle for our attention, from hoardings high up on buildings, from shop windows and newsstands, from the sides and backs of buses and commercial vehicles, or from the brightly illuminated panels of bus stops. This clamour of competing images is counterbalanced by an anarchic mosaic of spray-stencilled teasers, photocopied expositions, custom-made stickers and fly-posted sheets. Occupying unconventional spaces such as derelict shop-fronts and temporary hoardings, they are equally demanding of our attention but in a more subliminal and unorthodox way. A recent addition to this urban gallery of 'outside-the-line' communications has raised some interesting questions about the relationship of such commercial 'street art' to its context.

It would be an admirable feat to stand apart from both mainstream and underground genres of advertising. But this is exactly what mother's advertising campaign for britart.com has accomplished. This has been achieved not through the appropriation of new and generally unexploited sites – although the pavement posters realise this – but by hijacking certain familiar kinds of 'unofficial' advertising sites. Thus there are posters designed for trees, walls, ATMs and traffic-light junction boxes in conscious imitation of traditional flyposting, and others that are attached to safety railings, where we would normally expect to find advertisements for such ephemeral products as newspapers and Sunday supplements. But having commandeered these unconventional locations, the britart.com posters capture our attention by their startling use of what at first appears to be non-advertising copy. On plain white sheets we read what seem to be simple technical descriptions of the objects to which the posters have been attached. Only in a discreet lower corner do we eventually find any reference to the product being advertised, and this is only a web address. The irony is that these apparently self-referential descriptors are actually highly referential, alluding in a sophisticated way to the service offered by the website advertised.

In effect these posters are simply a familiar information system applied in an unfamiliar context, but it is this incongruity that draws our attention. The impact of this juxtaposition is amplified by the descriptions of the objects to which the posters are attached. They recreate the look and style of the labels applied to works of art in a gallery or sale-room context, but satirise the originals by their deadpan mimicry of manner(ism) and inclusion of witty observations:

**Lamp Post**    1981

    steel pole (hollow), glass, dog urine

    200 x 10 x 10cm

The information provided is sufficient to persuade us to look at the 'host' object in a fresh light, but equally these posters create an abstract intellectual link to the thing that they are promoting, which is an on-line arts service. Their association with contemporary art is so compelling that there are anecdotes of people attempting to collect the series, and their ostensible status as art object is underlined by the presence of a red dot in one corner, as if the poster has been acquired by a collector.

The britart.com campaign fascinates on another level because it deals with the issue of how a product in one medium, in this case a website, can be advertised in another very different medium. Of course, on-line companies need to establish a presence in the physical world in order to draw people into their virtual space. But this campaign makes no attempt to refer to the visual language or content of the britart.com site, and instead relies on the curiosity generated by a witty campaign to persuade the public to visit the website.

Digital Lab: Print & Electronic Design       advertising    britart.com

# Junction Box  1971

steel, paint, wiring, electricity.
100 x 120 x 50cm

britart.com

Digital Lab: Print & Electronic Design  advertising   britart.com

# Railing     1971

metal rods, paint, hand prints.
300 x 100 x 5cm

*Engaging three dimensional essay on containment.*

art you can buy **britart.com**

# Junction Box    1971

steel, paint, wiring, electricity.
100 x 120 x 50cm

*Taken from the artist's Traffic Triptych.*

art you can buy **britart com**

### 0.1  campaign

As with most campaigns it is important to consider how the development and visual resolution relates to a company's perception of themselves.

"Britart is dedicated to bringing both emerging and established British artists to a wider audience. We believe art should inspire the many, rather than being jealously guarded by the few. Buying original art need not be an intimidating experience, we're here to make it as simple as possible. We have thousands of quality works by hundreds of talented artists. Contemporary art for every choice."

britart.com press release

A major function of the campign is its presence in a wide variety of locations. Street furniture is utilised to carry messaging normally appropriate to low-grade advertising, nightclub flyers and stickers.

The advertising is targeted at concentrated areas of creativity: Baker Street, Angel of Islington, Farringdon, Covent Garden, etc. The careful control of this site-specific advertising not only facilitates its exposure to the target audience, it also minimises costs and therefore improves the profitability of the campaign, which is of paramount importance when working to a restricted budget.

"By putting Britart out in the street, the campaign has shown in a simple way that contemporary art doesn't just belong in the gallery."

Digital Lab: Print & Electronic Design  advertising   britart.com

## Pavement    1962

concrete slabs, cement, shoe prints,
dog excrement, chewing gum.
8000 x 15050 x 10cm

*Regimented mosaic.
Companion piece to road by the same artist.*

art you can buy **britart.com**

## Lamp Post    1981

steel pole (hollow), glass,
dog urine.
200 x 10 x 10cm

*Totemistic work representing man's beacon
on the existential world.*

art you can buy **britart.com**

## Wall    1946

mixed media installation: bricks,
tiling, wood, insulation, nails.
2256 x 425cm

*Rebuilt 1956.*

art you can buy **britart.com**

Digital Lab: Print & Electronic Design         advertising        britart.com

## 0.2 brainstorming

When an advertising campaign is undertaken, the sentiment of the message must be considered before it is developed – a case of form follows function. Simple, clear statements are generated that are to become the basis of the campaign. Reflecting the mission statement of the company we find the occurence of themes such as 'art should inspire' and 'art need not be an intimidating experience'.

During the generation of the project a 'mind map' was created for two purposes. It allowed creatives to explore notions of the brand, placement of a potential campaign, and to resolve the sentiment and purpose of the project – "Britart should stand for the democratisation of art". And it demonstrated a train of thought to a client. Usually the mind map would appear in the form of 'mood boards' illustrating a progression towards a solution. In keeping with the mood of the final campaign, the work in progress and development of ideas is both sophisticated and direct – 'art without the bollocks' – which may sound flippant, or even radical, but is actually faithful to the intentions of the brand.

Digital Lab: Print & Electronic Design     advertising     britart.com

HOW TO BECOME AN **art connoisseur**™

£50 for every reader* plus chance to win art worth **£2500** See below for details *To spend on purchases of £200 or more from britart.com

"Now I can wear my art beard™ and ponder with confidence."
Paul Adams, previous winner

**Step 1** Go to www.britart.com and find the piece of art called "Jarvis Cocker" by Francis John Pool.

**Step 2** Click on the starburst, under the piece of art, to claim £50 off any art worth £200 or more **PLUS** your chance to win £2500 of art from Britart.com. If you win celebrate by wearing your free art beard™.

**Step 3** See the Observer tomorrow for another exciting opportunity to win £2500 of art and qualify for another £50 offer.

britart.com
art you can buy

The **Guardian**

**call to action**

The audience is asked to participate and, in the spirit of the campaign, become an art connoisseur™.

**incentive**

An additional enticement is offered.

**sign off**

Traffic is driven to the website which the reader must visit in order to become involved.

Digital Lab: Print & Electronic Design    advertising    britart.com

Digital Lab: Print & Electronic Design        advertising    britart.com

## 0.3 product

preview paintings™

**Preview paintings™** offer potential buyers the opportunity to see what a piece of art will look like in their house prior to purchase. Sympathetic to the nature of the campaign, they consist of humourous and ironic propositions that add personality to the brand, while subtly asserting that control is with the viewer.

art pencil™

The **art pencil™** is suitably tongue-in-cheek with its declaration that 'with this pencil everything you draw becomes art', reaffirming the assertion that control is with the viewer and not the viewed.

artalizers™

With **artalizers™** the sentiment of bringing art into peoples' homes is taken to extremes, inviting you to decide what constitutes art. A series of stickers, 'Wall – Bricks, Mortar, Drainpipe', for example, both mock art and make it more accessible.

tv paintings™

Consisting of a video containing looped stills of artworks, **tv paintings™** allows prospective buyers to view paintings in their own home. Subverting the importance of painting through the medium of television, the value and uniqueness of art is brought into question. In accordance with the values of the campaign, 'art without the bollocks', everybody is able to access art which would often be exclusive due to its value.

Digital Lab: Print & Electronic Design        advertising    britart.com

# Creative team at mother

## comments

**project credits**

**mother**
200 St John Street
London EC1V 4RN
UK

T  +44 (0)20 7689 0689
F  +44 (0)20 7689 1689

**E-mail** mother@motherlondon.com
**www.motherlondon.com**

Digital Lab: Print & Electronic Design                              advertising          britart.com

"Britart.com is an on-line gallery selling contemporary British art. The idea behind the company is to make real art accessible to everyone and to make it available at reasonable prices. At the moment, galleries and other public spaces are closed, slightly intimidating environments where people can look at art. However, it's not that easy to actually buy art and take it home immediately. Britart therefore is a means of bringing art to the people in a very literal sense.

"At first we started thinking about what the brand should stand for, how their services could be made better and how the company could adopt a more appropriate tone when communicating its message. Should the stance be militant, or naive? Perhaps a more common-sense approach to art was preferable? Or should Britart sound like a car rental company?

"The result of this discussion was a decision to make art more human, more approachable and down-to-earth. In other words, Britart should stand for the democratisation of art. We created an enormous mind map for the client with areas of communication, advertising, website ideas, stunts, sponsorship areas, tone of language, quotes and PR products. And all of these surrounded one simple sentence: 'Art without the bollocks'.

"We also looked at the logo. Our goal was to make a simple, recognisable format for everything that comes from Britart. Strong but not too dominant. We also thought about the '.com' part, asking ourselves whether it should be a part of the logo or be added as a part of the text for each appearance in print. In the end, we decided to keep it in as we developed an idea based on an established 'art world' thing: the red dot. The red dot when applied to a piece of art in galleries means 'sold'. (It's usually placed in the bottom corner of paintings on display.) We took the red dot and made it much more visible by using a fluorescent orange colour so that it would stand out against the black-and-white profile we'd given the rest of Britart.

"For the advertising (and with a budget that pretty much disallowed traditional media choices), we came up with a creative flyposter/sticker campaign as part of a wider product range aimed at journalists to get Britart as much publicity as possible.

"The first product was the conceptual art pencil™, which claimed to make every scribble a piece of art. This was followed by tv paintings™, a collection of paintings/a lo-fi showcase on videotape for home use ('12 minutes on each painting to brighten up the dullest dinner party'). These two items were designed to make people think about having real art in their homes but also to show that reproductions are not as good as the real thing.

"Later we released artalizers™, a couple of sheets with small art plaque stickers for use at home or in the office. 'Turn your home into an art exhibition' was the selling message. A second sheet of artalizers™ – customised for office use – was sent out as a business-to-business mailer, and then we ran the artalizers™ as a sticker insert advertisement in Time Out magazine. Once again, we adapted them so that they could be stuck on everything from people to pint glasses.

"Our latest Britart product, preview specs™, comprises lightweight paper spectacles with an extension arm in front, designed to hold tiny preview paintings™ from a sample sheet in the same pack (i.e. a selection taken from Britart's portfolio). Preview specs™ are perfect for 'trying out' art and with them, as the copy on the pack says, 'choosing art for your home has never been easier!' We're currently running advertising for this product as a substitute for straight britart.com advertisements. In this way, people can log onto the website and order a pair totally free of charge.

"The accompanying flyposter/sticker campaign featuring art plaques™ was born of the same thinking as the Britart logo. Once again appropriating something familiar in the art world, we designed posters based on conventional gallery plaques to be applied in unusual places and on unusual objects, with the aim of transforming 'the ordinary' into works of art. The goal was to grab people's attention but also to make people think differently about both contemporary art and their own surroundings. Flyposting witty and engaging messages seemed the perfect way to convey the idea that 'art is everywhere', and we ended up making eight different plaques: Wall, Bridge, Cash Machine, Tree, Pavement, Junction Box, Railing, and Lamp Post.

"The whole campaign has been incredibly successful, given the limited budget, generating not only interest in Britart but also debate on the effectiveness of intelligent ambient advertising. Encouragingly, many people have bought into the idea that contemporary art should be accessible and not something exclusive to be discussed in hushed tones by a handful of black polo-neck wearing art trendies in Hoxton. By putting Britart out in the street, the campaign has shown in a simple way that contemporary art doesn't just belong in the gallery or – for that matter – up its own backside. It does have a sense of humour and can play a stimulating role in daily life, both in the home and the work place."

Digital Lab: Print & Electronic Design    advertising    jimmy grimble

# project 0.2 jimmy grimble

**The power of advertisements lies in their ability to be evocative, provocative, to induce desire and to express emotions – the images that we see on the streets, in magazines and invite into our homes all embody these functions to some extent. Nicework's poster campaign for the film Jimmy Grimble attempts to achieve this in a style which is seen infrequently in the language of promotional film posters. Images of the headlining actors and scenes from the film are omitted in favour of an illustrative approach featuring a generic image of a young boy – a 'catch-all' figure with broad appeal to the target audience of teen and pre-teen males. Similarly, the names of the actors are played down and incorporated into the overall visual style of the poster.**

The agency utilised a complex process to generate the artwork for the campaign involving, in the first instance, hand-rendered illustration. The computer was then used as a resource (not a source) that enabled multiple revisions and alterations to be accommodated at speed, while retaining the illustrative qualities of the artwork. A rich tapestry of layered images was composed of multiple drawings and sketches, resulting in final visuals reminiscent of a sketchbook.

There are specific difficulties in condensing 90 minutes of moving images into a static, stand-alone piece of print without losing the dynamic essence of film. The piece, although deceptively simple, has to work on several levels: it needs to generate sales, it needs to entice a prospective audience and it needs to be true to the film. A viewer may feel deceived if there is no relationship between the promise (the poster) and the reality of the product (the film). In this example the montage of imagery attempts to encapsulate the personality of the film. With the abstraction of cityscapes and the reference to youthful optimism, there are indications of the broader narrative of the story.

We understand from the agency that the film received little box office or critical success, and this brings into question the effectiveness of advertising, when many other factors are involved in the success or failure of a product. In the case of films these factors would include the expectations of the target group and the quality of the script, direction and acting. There are many examples of good design that fail to bring commercial success, and countless more examples of bad design that is highly successful. This is not because consumers have no understanding of design values. It is because design and advertising are only elements in an overall scheme of brand values, public perceptions and the true nature of the product. Without an honest and symbiotic relationship of company and product, can advertising realistically be expected to succeed?

Digital Lab: Print & Electronic Design        advertising        jimmy grimble

Digital Lab: Print & Electronic Design　　　　　　　advertising　　jimmy grimble

## THERE'S ONLY ONE Jimmy Grimble AND NO SUBSTITUTE FOR LIFE

### 0.1　sketching

At the beginning of the project visual source material is collected and a process of experimentation and illustration begins. At this stage various themes begin to emerge, and a development of football imagery is pursued. During this stage the work is in a mixture of formats: in sketchbooks, as flat artworks and as computer-generated drawings.

In an industry dominated by technological advances it is refreshing to find visual material that isn't conditioned by the computer's capabilities, but rather is enhanced by the possibilities it can bring to the more traditional techniques of illustration.

22

Digital Lab: Print & Electronic Design            advertising      jimmy grimble

Digital Lab: Print & Electronic Design    advertising    jimmy grimble

### 0.2 typography

The typography is treated in a similar way to traditional image- and print-making. In the first instance type is hand-drawn, before being traced on the computer to allow for additional manipulation. Fonts are created, altered and experimented with to create unique and specific logotypes. As the text elements are now computer illustrations, colours, line widths and size can be easily changed.

24

Digital Lab: Print & Electronic Design  advertising   jimmy grimble

**THERE'S ONLY ONE Jimmy Grimble AND NO SUBSTITUTE FOR LIFE**

TOUCHSTONE PICTURES PRESENTS A WORKING TITLES FILMS PRODUCTION IN ASSOCIATION WITH DOGSTAR FILMS/NEW CRIME PRODUCTIONS A STEPHEN FRIARS FILM ROBERT CARLISLE JIMMY GRIMBLE RICHARD FERREIRA HAYES GERALD BEDEKER BRYAN E BARTLETT KYLIE MORRIS PAUL VOSLOO MUSIC BY LIPHOOK COSTUME DESIGNER KATE FERREIRA HAYES FILM EDITOR JACKSON JEFFERY JACKSON PRODUCTION DESIGNER MARK SCANTLEBURY DIRECTOR OF PHOTOGRAPHY SEAMUS McGARVEY CO PRODUCERS JOHN CUSACK MR PINK EXECUTIVE PRODUCERS MIKE NEWELL "THERES ONLY ONE JIMMY GRIMBLE" SCREENPLAY BY BB KING AND JULES HOLLAND DIRECTED BY HOMER SIMPSON

**Jimmy Grimble**

TOUCHSTONE PICTURES PRESENTS A WORKING TITLES FILMS PRODUCTION IN ASSOCIATION WITH DOGSTAR FILMS/NEW CRIME PRODUCTIONS A STEPHEN FRIARS FILM ROBERT CARLISLE JIMMY GRIMBLE RICHARD FERREIRA HAYES GERALD BEDEKER BRYAN E BARTLETT KYLIE MORRIS PAUL VOSLOO MUSIC BY LIPHOOK COSTUME DESIGNER KATE FERREIRA HAYES FILM EDITOR JACKSON JEFFERY JACKSON PRODUCTION DESIGNER MARK SCANTLEBURY DIRECTOR OF PHOTOGRAPHY SEAMUS McGARVEY CO PRODUCERS JOHN CUSACK MR PINK EXECUTIVE PRODUCERS MIKE NEWELL "THERES ONLY ONE JIMMY GRIMBLE" SCREENPLAY BY BB KING AND JULES HOLLAND DIRECTED BY HOMER SIMPSON

Digital Lab: Print & Electronic Design    advertising    jimmy grimble

### 0.3  background

The final background is constructed in several layers, from a variety of sources – with high resolution photography being merged with illustrative layers and filters. Adobe Photoshop is used to control the colour balance of the cityscapes and paintings to create a textural and non-specific yet intriguing backdrop for the poster. This file is saved at the same size as the final poster, at 300 dots per inch (dpi), creating a 60 Megabyte (Mb) file.

### 0.4  illustration

Additional elements for the poster are created separately in Freehand drawing packages and imported into the document. Exported EPS files are rasterised into separate layers above the finalised background imagery. Illustrations are drawn firstly by hand and later redrawn or traced into the computer for final manipulation and treatment. At this stage, colours, brightness, contrast and size can be manipulated with ease and speed.

Digital Lab: Print & Electronic Design                    advertising        jimmy grimble

### 0.5 elements

The various typographic elements and logos are created separately in Freehand and imported into a new artwork layer in Photoshop. Any further adjustments are made to the layout and final considerations of colour balance are introduced. The type is kept on a separate layer to allow alterations and changes to be executed easily – only at the final stage are the layers merged to create a single image for artwork.

### 0.6 technique

Using the layers palette the illustration can be controlled using 'multiply' and 'screen' values, creating the impression of a textural silk-screened artwork. Blended colours can be applied across illustrations, and the layering of the elements adjusted until the values are correct.

Digital Lab: Print & Electronic Design          advertising     jimmy grimble

# Mark Scantlebury, director at

## comments

**project credits**

| | |
|---|---|
| **Art Director** | Richard Hayes |
| **Designer** | Paul Vosloo |

**Nicework**

14A Clerkenwell Green

London EC1R 0DP

UK

**T** +44 (0)20 7253 8181

**F** +44 (0)20 7253 8282

**E-mail** mark@asylumdesign.co.uk

www.nicework.co.uk

Digital Lab: Print & Electronic Design    advertising    jimmy grimble

# Nicework

"The film company wanted a poster that had a youthful and cool feel and didn't follow the format usually applied to film poster design – a strong and identifiable photographic image of the star with the title of the film identifiable at 25 metres. The film was about football but the producers wanted to give it a broader appeal than that. They wanted to give the poster an urban, music feel rather than sporting. Their brief to us was to produce a poster that a 15–18 year old boy would like to have in his bedroom. The use of stills from the film or location publicity shots was contractually difficult. The young star was unknown and there was not a shot of him strong enough to carry a poster. These constraints sent us down an illustrative route.

"We started by trying to use stills. The producers felt none were strong enough or were too sporty. Amongst our first drafts was an illustration similar to the final poster. Everyone felt that this was the route to follow. The poster design was very distinctive and unusual for a film. The film company and the producers were very happy with the poster when they were presented with our execution. In the end the film did not do well critically or at the box office. It is difficult to say what part the poster played. It may even have been a positive influence. But then how influenced are people by the poster? The most important ingredient in a film's success is the presence of an American star (particularly to cinema-goers under 25) and word of mouth – which is essential to the success of a small-budget British film. The soundtrack to the film relied heavily on pop music. There was an album to accompany the film. The poster artwork was used on the album – I feel that it was in this format and in the music 'environment' that it was most successful. The record label were very enthusiastic about the album cover."

# project 0.3 buddy lee

The marketing of denim clothing presents challenges that are peculiar to this product. Denim garments are arguably very similar – the fabric, although subject to the individual styling and tailoring of a particular brand, is highly recognisable in whatever incarnation it takes, and betrays its utilitarian origins. The brand, rather than the aesthetic of the product, necessarily becomes the driving factor of the marketing in order to distinguish one denim product from another. In the three advertisements and related media in Lee's Buddy Lee campaign, launched to promote a line of dungarees, this trend is taken in a new and progressive direction. The focus is not the brand per se, or even the product specifically, but a broad narrative that spans a raft of promotional media, including television and ambient marketing, and which uses the worldwide web as its hub. As the narrative needs not explain the product, it has the potential to surpass the expectations of fashion advertising.

In advertising agency Fallon Minneapolis' 'Buddy Lee Challenge', an heroic fictional character is the focus of the campaign. Buddy Lee – a doll-like character from the 1920s discovered in the Lee Apparel Company archives and resurrected for the contemporary market – speaks directly to an audience of 17–22-year-olds, and personifies an alternative set of values. Buddy Lee is ironic, cool and understated, and the audience can interpret this stance as unpretentious and credible.

The television advertising strand of the campaign combines live action and animation to convey simple comic-book stories within which Buddy Lee, seemingly against all odds, emerges as the victor. The slapstick humour of early cartoons is recreated, with characters surviving electrocutions, laser bolts and high-speed crashes. The narratives are simple enough to be instantly engaging, and while we know that Buddy Lee will be victorious, the level of humour, seamless direction and timing of the advertisements is such that they are delightfully captivating. The narratives have a simple sense of morality, with good conquering evil and winning being the reward for playing fair.

The advertising works on two levels: firstly to increase awareness and presence of the brand, and secondly to direct people to the crucial web-based strand of the campaign, where they can challenge the various villains to on-line interactive games. This gaming component has the ability to draw potential customers back to the site again and again, to improve on their scores and compare their prowess with other players. It then directs players to the Lee retail outlets, where 'secret codes' are found on Lee Dungarees products, enabling advancement to higher gaming levels. This seamless combination of marketing strategies demonstrates the campaign's thorough and adventurous use of a broad range of media, successfully leading the audience through the narrative from conventional sources of advertising, to the interactivity of the web, and subsequently to the Lee stores.

"This campaign truly demonstrates marketing in the new economy," said Gordon Harton, president of the Lee Apparel Company. "A teaser campaign drives consumers to the web to learn about the challengers; television spots solve the mystery behind the teasers and drive viewers back to the web, allowing consumers to join the challenge and ultimately, to purchase products."

A major benefit of this consumer pattern is that it allows Lee and Fallon Minneapolis to immediately access the effectiveness of the advertisement-to-internet executions through tracking information obtained at these touchpoints. "This campaign, like none I've seen before, provides us with built-in tools to measure its impact on brand awareness and sales," said Harton. "We believe this is the direction marketing is going. We're excited to be leading the charge."

Digital Lab: Print & Electronic Design                    advertising        buddy lee

Digital Lab: Print & Electronic Design    advertising    buddy lee

32

Digital Lab: Print & Electronic Design　　　　　　　　　　　　　　　　advertising　　　　buddy lee

**MR. O**

THE BUDDY LEE CHALLENGE, FALL 2000.

## 0.1 schematic

In the early development of the project, Fallon Minneapolis devised a strategy for the campaign, depicted in the schematic to the left. This visualisation of intention becomes an important process both internally within the agency, and also for external communications with the client. In this way, a complex pattern of consumer behaviour is clearly and concisely described.

A timetabled programme of action is formed as the agency plans to introduce the Buddy Lee character through flyposting, and then to maintain his presence through related media.

The plan demonstrates the fundamental purpose of advertising – to get potential purchasers to the point of potential purchase. However it also demonstrates the complex processes involved in this. In such a media-saturated sector as clothing, and with so many rivals vying for the attention of increasingly fragmented consumer groups, we begin to understand why agencies are now looking towards alternative media.

## 0.2 initial ideas

In the early development of the campaign, marker visuals are used to quickly work through ideas – it is interesting to see how similar the final television slots are to the above visuals depicting characters fighting (p.40).

Digital Lab: Print & Electronic Design  advertising  buddy lee

### 0.3 gaming

Increasingly we find a symbiosis between the traditional methods of advertising – print, magazine advertisements, radio, billboards, etc. – and the emerging and expanding capabilities of new media, internet virals and even placement within gaming experiences.

It's long been understood that an effective method of advertising is to become intrinsically linked to, and integrated with, audiences' pastimes. For example, the association of companies with sports teams – especially as many personalities and teams are now regarded as some of the largest international 'brands' – has proven to be of great mutual benefit.

By engaging an audience in an activity that they would normally do, in this instance playing on-line games, exposure to a brand is increased. This, from an advertiser's point of view, can only be beneficial.

Digital Lab: Print & Electronic Design        advertising    buddy lee

**The Buddy Lee Challenge Games.**

The general game idea:

After seeing the commercial on TV you can log-on to buddylee.com and continue to interact in the Buddy Lee Challenge. In all games you are Buddy and you are going to beat Gorgo, Curry and Ikki.

All the games have a similar visual language as TV. All games also have two levels. You may only enter the second level if you have a certain code (which you can only find on a pair of Dungarees), which you can easily find at any Dungarees retailer.

Gorgo Challenge.

You're Buddy and you're going to beat Gorgo. You select one of three balls to try to score. One of them (or maybe two) are prepared with dynamite and might explode if you take too long. You have to decide whether or not to take a shot (which is not as time consuming but harder), or to dribble and make a safe basket but running the risk of having the ball explode in your hands.

Ikki Challenge.

In this game you are going to try to shave the bearded lady, Ikki. You got three tools to help: A pair of scissors, an old-fashioned shaver and an electric shaver. If you use too much "power" and happen to cut Ikki three times, you loose. However, if you have a gentle and smooth touch, you will find out that Ikki is really good-looking when the beard comes off.

Curry Challenge.

A traditional, simple skill/speed game where you race against the dare-devil Curry on different courses.

Digital Lab: Print & Electronic Design    advertising    buddy lee

# WELCOME TO MY PHOTO ALBUM.
### Here are a few things that I've hit this week:

*A nice Spanish acoustic guitar.*

*A delicious Greek farmer bread.*

*A pint of good ol' brew (pale ale).*

*A cutting-edge Japanese boombox.*

**0.4   virals**

Internet virals consist primarily of short, witty, collectable e-mail movies or attachments which are 'released' with the aim of self-generating their distribution and scope. In the Buddy Lee campaign the virals concentrate on the three more left-field, 'anti-hero' characters.

The purpose of these virals is to direct traffic to the specified site. At the end of each 30-second movie the closing frames are of a web address where we have access to further information about the characters.

After watching 'Roy' destroy items with a sledgehammer we find ourselves looking at his archive of other destroyed objects. The virals are self-sufficient, that is to say they carry no branding, and are distinctly 'home-made' in their appearance. With a strange, almost unnerving quality to the slots, we find ourselves unsure if we are watching something commercially manufactured or produced on a home PC.

Digital Lab: Print & Electronic Design          advertising     buddy lee

DA NUMBER ONE (0:27)

supergreg.com

1 | BEER — BREAD

I'm mister Demolition,
I'm big, bad Roy,
I'm mister Demolition,
born to destroy.
                    -Roy.

www.borntodestroy.com

TIGER
LEVEL Master Gold Edition
(For Special Occasions Only)
ACCURACY 98%

PICK-UP-A-CHICK
by Curry
WINNING MOVES
FOR ONE-ON-ONE SITUATIONS.

www.rubberburner.com

Digital Lab: Print & Electronic Design        advertising        buddy lee

### 0.5 websites

Each of the anti-heroes within the campaign has their own intriguingly realistic website. They all have a genuine 'amateur' feel – leaving us unsure as to whether these are indeed real. The sites go into great levels of detail about the interests and pastimes of the characters – adding to the depth and success of the campaign.

### 0.6 television slots

The television slots (p.40) are scripted and visualised, at which time decisions are made as to the appearance of the characters. In this example the character in the karate suit is eventually played by John Randle of the Minnesota Vikings in the final filmed television slot.

Digital Lab: Print & Electronic Design    advertising    buddy lee

# THE BUDDY LEE CHALLENGE

**The Buddy Lee Challenge, TV.**
Buddy Lee vs. Ikki - "The Martial Arts Expert"
30 seconds.

Buddy Lee is challenged by a huge, bearded lady called Ikki.
    Ikki is a martial arts expert and wants to kick Buddy's butt.
    To supervise the fight we'll find a young, handsome guy in the traditional striped ref shirt and a pair of Dungarees.
    As soon as the ref gets the fight started (GREAT SHOT OF JEANS) it's obvious that the bearded lady is going to kick Buddy's butt. Ikki is for real and she is severely beating Buddy.
    For a moment you'll wonder how Buddy is going to manage to get out of this nasty situation. Hope fades until the bearded lady suddenly stops and looks confusedly at Buddy.
    As we CUT TO Buddy we see that Buddy is positioned in the famous "seagull" pose from Karate Kid.
    Unfortunately, Ikki knows how to handle that too. She pulls out a laser gun from the inside of her Japanese martial arts jacket and shoots Buddy, aiming on his jeans.
    The laser beams are "cute". They move extremely slow and in groups of three. When they reach Buddy they bounce "friendly" on the rivets of his jeans (CLOSE-UP) and back towards the bearded lady. The bearded lady realizes that the three laser beams are heading toward her and that she is in deep trouble.
    She decides to flee the ring.
    Buddy wins.
    In the final picture, we see how Buddy thanks the bearded lady for a good fight and hands over a new pair of Dungarees.
    She hugs Buddy.

Digital Lab: Print & Electronic Design        advertising        buddy lee

40

Digital Lab: Print & Electronic Design    advertising    buddy lee

**0.7   roy**

In a television slot we find All-Pro Defensive Tackle John Randle of the Minnesota Vikings, as the anti-hero Roy, wanting to karate chop Buddy Lee. It's an obvious mismatch – but as we know Buddy Lee never backs away from a challenge.

Digital Lab: Print & Electronic Design       advertising    buddy lee

Digital Lab: Print & Electronic Design     advertising     buddy lee

**0.8  super greg**

In another slot we find Super Greg, a "famous, fabulous DJ", engaging in a mixing contest with Buddy Lee. Buddy enlists the help of an electric eel to enhance his mixing skills, and even when it seemingly goes wrong (Buddy gets electrocuted and flies from the decks), the advertisement ends with Buddy as the hero through his breakdancing abilities.

Digital Lab: Print & Electronic Design          advertising     buddy lee

44

Digital Lab: Print & Electronic Design     advertising     buddy lee

### 0.9 curry

This quirky spot reveals exactly what challenge the villain has in store for Buddy Lee – and just how far he will go to bust him. Race-car driver Curry, in his quest to impress the beautiful female judge by winning a race, runs Buddy Lee off the track. While most mortals (and dolls) would have been destroyed, Buddy Lee comes through unscathed. While he loses the race, he wins the heart and admiration of the judge – Australian model/actress Annalise Brakensiek.

Digital Lab: Print & Electronic Design    advertising    buddy lee

# Creative team at

## comments

**project credits**

| | |
|---|---|
| Creative Director | David Lubars |
| Group Creative Director | Mike Lescarbeau |
| Art Director | Paul Malmstrom |
| Copywriter | Linus Karlsson |
| Producer | Brian DiLorenzo |
| Account Management | Bruce Tait, Chris Lawrence, Kristin Roessler |
| Account Planning | Julie Smith |
| Media Planning | Bill Morgan |
| Production | Harry Nash, London |
| Director | Fredrick Bond |
| Director of Photography | Carl Nilsson |
| Executive Producer | Helen Williams |
| Editor | Rick Russell |
| Post-production | The Mill, London |
| Music | Pepe DeLuxe, Helsinki, Finland |
| Sound Design | Rohan Young, Scramble, London |
| Audio Post-production | Scramble, London |

**Fallon Minneapolis**
901 Marquette Avenue, Suite 3200
Minneapolis, MN 55402
USA

T +1 612 321 2345
F +1 612 321 2346

www.fallon.com

Digital Lab: Print & Electronic Design  advertising   buddy lee

# Fallon Minneapolis

The Lee Apparel Company is a division of the VF Corporation – the largest publicly held apparel company in the world. Lee manufactures and markets denim jeans and related apparel, casual pants and shirts. Lee is headquartered in Merriam, Kansas – just outside of Kansas City.

"Fallon Minneapolis manages the consumer voice of some of the world's leading brands. With billings of approximately $575 million, the agency's clients include, among others, BMW of North America, drugstore.com, EDS, Holiday Inn, International Truck and Engine Corp., the Lee Apparel Company, Nordstrom, Nuveen Investments, PBS, Ralston Purina, Starbucks Coffee Company, Timex and United Airlines. Fallon Worldwide is the newly formed second global network of Publicis Group, based in Paris.

"In the fall of 1998, the Lee Apparel Company embarked on a long-term brand building effort to make their jeans cool again for younger consumers – the lifeblood of the denim business and an audience whose perceptions of the brand to date had been summed up by one simple quote from an 18-year-old male, 'Lee is for my mom and her fat (ass) friends'.

"The 1998 launch of Lee Dungarees, a new silver bullet sub-brand, centred on an icon named Buddy Lee, who was literally resurrected from Lee's 110 years of archives. Buddy Lee originated in the 1920s and came to represent all that was good about Lee jeans: heritage, authenticity and durability.

"By the fall of 1999, Lee was experiencing positive momentum with the largest target audience of men and women: ages 17–22. The brand imagery ratings were up, there was a share growth among the target and over two-thirds of the target audience was aware of Buddy Lee. While Lee Dungarees was increasing unit share in its tier of distribution, overall unit volume in the tier was in severe decline. We were becoming a bigger piece of a smaller disintegrating picture. Suddenly the long-term brand building effort behind Lee needed to address a serious channel problem; we had to get young people to want our brand so much that they would seek it out in a distribution channel they had routinely abandoned.

"The campaign started with the equity built in Buddy Lee as an icon of Lee's indestructable spirit and 'Man of Action' attitude. Our creative strategy was truly a fully integrated approach, using the web as the linchpin of the campaign. The creative idea leveraged the interest and enthusiasm for Buddy Lee by dramatising his heroic stature and 'Can't Bust 'Em' spirit through encounters with villainous, anti-hero characters in the 'Buddy Lee Challenge' games on buddylee.com. Mechanisms such as the worldwide high-score list created an even deeper relationship with the consumer on-line. Consumers advanced through game stages by finding and entering a unique code – only available on the product at selected retailers – that acted as a password. The website provided a view of the updated product and directed consumers to nearby retail locations."

# project 0.4 queercompany

Juxtaposed image and text have long been the basis of graphical and advertorial communication, often eliciting unexpected nuances of meaning. Multiple interpretations can be created through the considered placement of visual reference and the printed word. This can be used with great success by a company intending to establish a resource for an otherwise ostracised sector of society. Although excluded far less in the current social climate, there still exists a stonewalling of the gay community in relation to financial products such as insurance and pensions. The queercompany.com website provides these critical services to the gay community, in addition to a range of entertainment services including travel, bar listings and restaurant guides. The challenge faced by advertising agency Anti-Corp was to produce a campaign which appealed to a diverse range of communities, encompassing gay men and women, bisexuals, trans-gendered people and straight people, while retaining a legitimate and credible persona that would inspire confidence in the client's services.

The two higher-profile advertisements of the campaign – 'Thank God for women', which appeared at the Centrepoint site in central London, and 'Thank God for men' which ran in tandem with the former on the Underground and in various national newspapers – adopt the commercial portrayal of beauty, the models being uncommonly beautiful and flatteringly portrayed in glamourous black and white. Upon first view one may consider this a dishonest ideal of homosexuality – the models appeal to the fantasies of heterosexual men and women, and may not relate to the communities which they profess to portray. But this approach shrewdly subverts and exploits the language which it has adopted, enabling communication with a mainstream audience in a manner with which the audience is familiar and which it accepts. The campaign can then assert that the gay community is as worthy of equal consideration and treatment as the straight community. This disarms initial knee-jerk prejudices or apprehensions, and encourages potential customers of all persuasions to investigate the website, and to experience the notion of 'queer' as a sensibility, not merely a sexual orientation.

The headlines complement the photography in their use of a bold black font upon a stark white background, and enhance the impact of the pithy and sometimes wryly ambiguous messages. 'Thank God for women' initially evokes the type of bawdy comment that an FHM-reading 'lad' might utter when confronted with an image of two attractive, scantily-clad females embracing. But further consideration uncovers the assertion that all people are equal in the eyes of God, and that gay females are worthy of celebration by all communities, regardless of their sexual orientation. And a further subtext is revealed in a challenge to religious doctrines which ostracise homosexuals. In this single advertisement, the juxtaposition of a black-and-white image with four carefully chosen words articulates a stratum of meaning that implies the discussion of a narrative greater than merely the promotion of a company.

The advertisements were produced in an exceptionally short period of time. After a parting of ways with the original agency, the newly appointed creatives produced the work in under a week. This is testimony not only to Anti-Corp's ability, but also to the dedication of a client who both controlled and was active in the direction of the campaign: "We wanted queer advertising, not gay advertising." A culmination of phenomena is embodied here: a need for social change; a client brave enough to elicit that change and an agency able to interpret their needs. These advertisements exemplify advertising's ability not only to respond and react to social change, but to explicitly influence it.

Digital Lab: Print & Electronic Designadvertisingqueercompany

Digital Lab: Print & Electronic Design       advertising       queercompany

# Thank God for men.

www.queercompany.com

### 0.1 photography

The photography, shot by world-renowned photograher Tom Stoddart, has a highly finished, commercial quality. But this conceals an atypical approach to the casting for the shots. These models aren't all professional models; the contracts were offered in open competition for the face of Queercompany, with the only prerequisite being that of sexual preference – the models had to identify as queer.

Even the agency name, Anti-Corp, implies that all is not as it seems. While it would be inaccurate to assume that the agency operates outside the remit of commercial practice, here is yet another sign that there is a greater narrative being discussed than that implied in the campaign.

### 0.2 press advertisements

The press advertisements adopt a more demanding and confrontational approach to the reader – a tack that would not have been appropriate for the highly visual billboard campaign for fear of provoking a backlash to the direct challenges which the advertisements offered.

"I'm queer. And by the way, this is not an apology.", is both defensive and assertive, defying potential prejudice or disapproval.

"If you think telling your parents that you're queer is hard, try telling your daughter.", points out the difficulties often faced by gay individuals, and implores the reader to consider these problems sympathetically.

"When did you first know?", invites the heterosexual reader to consider an epiphanic moment, which they may never experience, with understanding and compassion, whilst expressing solidarity and empathy with both open and closet gay people.

"No white wedding. Sorry mum.", again offers a familial angle, but expresses emancipation and independence in defiance of expectations and of social strictures.

This strand of the campaign offers a more down-to-earth approach to queer issues, proposing characters and situations with which the audience may be more able to identify.

Digital Lab: Print & Electronic Design  advertising  queercompany

I'm queer.
And by the way,
this is not
an apology.

www.queercompany.com

No white
wedding.
Sorry mum.

www.queercompany.com

If you think
telling your
parents that
you're queer
is hard, try
telling your
daughter.

www.queercompany.com

When did
you first
know?

www.queercompany.com

**0.3  comment**

Henrietta Morrison, joint chairman of Queercompany explains, "The campaign we devised was the combined result of five years' thinking and a weekend's worth of activity! The brief for the campaign was to produce advertisements with soul. Advertisements that would move and inspire people and leave them feeling profoundly touched. We hired one of the world's top photographers, Tom Stoddart, to shoot the bulk of the campaign. And to ensure the authenticity of the campaign, we specified that the models who auditioned had to identify as queer.

"We were all too aware of tacky gay advertisements appearing in the gay media which perpetuated the idea of the gay community being completely ghettoised. We were adamant that our campaign would appeal to the wider queer community and also that the campaign would appear in both gay and mainstream media.

"The specific result we wanted was for people to log onto the site and love it! What was also important to us was for gay women and men to own the campaign and to feel proud of it."

Digital Lab: Print & Electronic Design              advertising        queercompany

# Thank God for women.

**www.queercompany.com**

Digital Lab: Print & Electronic Design       advertising       queercompany

Digital Lab: Print & Electronic Design         advertising    queercompany

# Steve Bustin, events director at

comments

**project credits**

Mark Simmons, David Hieatt and Sy-Jenq Cheng

**Anti-Corp**

**www.anti-corp.com**

54

# Queercompany

"Our brief was that we wanted to make an emotional connection with our users, and to produce 'queer' rather than 'gay' advertising. To us, 'queer' is far more than just a sexuality – it is a sensibility, and our advertising needed to reflect this. 'Gay' advertising would have used stereotypical images and messages, whereas we wanted mould-breaking advertisements that would appeal not only to gay men and lesbians, but to bisexuals, trans-gendered people and straight people who would identify with the cutting-edge nature of our ethos and product. Anti-Corp understood the brief immediately, and acted upon it – the brief didn't really evolve. The campaign started in print media around launch, then moved onto billboards and the Underground. The launch phase included taking the first ever double-page spread in Metro (London's free newspaper for commuters), using the 'I'm queer. And by the way, that's not an apology' execution. This and three other executions then appeared in lifestyle sections of The Guardian, The Independent, Independent on Sunday, The Observer, Time Out magazine, the Evening Standard, ES Magazine and Metro. The advertisements also appeared in the lesbian and gay press, in the form of weekly freesheets in monthly magazines which include Attitude, Gay Times and Diva.

"Advertising space was booked in the Daily Mail, who initially refused to run the 'I'm queer' execution, but agreed to run the 'White Wedding' execution. Following extensive PR work and negative media coverage, the Daily Mail changed their minds and ran the 'I'm queer' execution.

"The billboard campaign used two new executions, 'Thank God for women', with a picture of two lesbians kissing, and 'Thank God for men' showing a male couple embracing. The 'Women' version was used on the giant Centrepoint billboard in Central London (19m x 10m), going up on 27th December 2000. Its unveiling was trailed by editorial in the Evening Standard, which was followed the following morning by coverage in virtually every national newspaper – except, for some unknown reason, the Daily Mail! The newspaper coverage was surprisingly positive – ranging from 'look at the lovely lezzas in their knickers' coverage in the tabloids to a more considered comment on the breaking of advertising boundaries by the broadsheets. Sunday newspaper columnists including Janet Street-Porter and Nigella Lawson devoted their columns to the advertisement, and The News of the World bought-up one of the models, and featured their own photo shoot of her in the paper and on their website. The advertisement was also covered around the world and across the net.

"Both executions then appeared on backlit billboards across London for two weeks, and on 48-sheet cross-track sites on Underground platforms. This was the first time that such overtly queer images had been seen on high-profile billboard sites."

Digital Lab: Print & Electronic Design     advertising    drd

# project 0.5 DRD

**Creative agency Faydherbe/De Vringer, based in The Hague, The Netherlands, continually produce some of the most dramatic contemporary print-based work around today. Their control and freedom with typography and image is not purely an aesthetic exercise; order, coherence and understanding are developed through the composition of their work. De Rotterdamse Dansgroep (later to become DRD), who are a community-based organisation, have specific needs in their advertising and promotion. A primary concern is one of consistent and coherent messaging – all the material must convey the core principles of the dance group whilst celebrating the individual differences of the company's performances over a period of time. The work shown in the following section is taken from the past few years of the dance group's performances and demonstrates the strong typography and imagery of Faydherbe/De Vringer's work.**

Throughout the series we can see the development of the DRD identity, with this becoming the pivotal point of the typography, both in message – DRD becomes the central point of promotion – and in typographical terms, with the compositions being centered around this point. The first poster produced was for a performance celebrating the 50th anniversary of the Marshall Plan (the Marshall Plan enabled the distribution of financial aid after the Second World War, by America to the countries in Europe which suffered the most through the German invasion). Following this initial 'trial poster' the advertisements began to take on a stronger, more unified presentation: 'DRD' became a logotype and point of focus, not simply an acronym of the dance group; the increased use of strong geometric coloured blocks created a coherence between the individual posters; and the particular strength and hue of the colours was again very much reminiscent of silk-screenings.

All the work shown is printed as offset lithography, with a variety of special colours, creating the textural qualities normally associated with silk screens – a quality reminiscent of Faydherbe/De Vringer's early theatre work which was often produced using the silk-screening process. Here we find the computer used in a completely transparent manner, all the work having been produced using QuarkXPress and Photoshop, yet remaining timeless in its appearance. The quality of these posters isn't hindered by the use of the computer, but instead is liberated. The typography is both free and fluid, with the imagery having a pure, expressive feel, free from unnecessary manipulation. With the computer enabling the absolute malleability of photography and type, this work is an example of how best to harness these capabilities without becoming seduced by them. If the designer has a clear understanding of the information he wishes to impart, a sound rationale for the method of communication, and the aesthetic capabilities to captivate an audience, then the temptation to impress through the computer's visual manipulation capabilities is removed.

The poster series shown here, and the attendant material, is an example of how a strong aesthetic vision has been generated to solve a specific graphical communication problem: how to successfully present a product in a media-saturated society in a manner that still engages and entertains. We have become all too familiar with the constant exposure of imagery and techniques that advertising brings, but here we find an example that retains a genuine and sophisticated aesthetic quality.

Digital Lab: Print & Electronic Design     advertising     drd

Digital Lab: Print & Electronic Design     advertising    drd

## 0.2 season 1997–98

Posters 1–3 were printed on the same day. The blue ink was identical in all three, to enable printing without the need to clean the press, thus saving money. The second colour was different in each poster.

A disadvantage was that because all of the posters were printed before the season started, much of the information was not finalised. Most of the dances were without titles so most of them were called 'new work'.

## 0.1 the U.S. connection

Poster for a special performance for the celebration of the 15th anniversary of the Marshall Plan.

**The U.S. Connection poster was produced using:** Photoshop + QuarkXPress

**Prints:** Blue pms 072 + red pms 032

**Size:** A1 (59.4cm x 84cm)

**Technique:** Offset

58

Digital Lab: Print & Electronic Design					advertising	drd

**Poster 1 was produced using:** Photoshop + QuarkXPress

**Prints:** Blue pms 540 + orange pms 1585

**Size:** A2 (42cm x 59.4cm) + A0 (84cm x 118.8cm)

**Technique:** Offset

**Poster 2 was produced using:** Photoshop + QuarkXPress

**Prints:** Blue pms 540 + red/brown pms 484

**Size:** A2 (42cm x 59.4cm) + A0 (84cm x 118.8cm)

**Technique:** Offset

**Poster 3 was produced using:** Photoshop + QuarkXPress

**Prints:** Blue pms 540 + green pms 397

**Size:** A2 (42cm x 59.4cm) + A0 (84cm x 118.8cm)

**Technique:** Offset

Digital Lab: Print & Electronic Design  advertising  drd

4

5

**0.3 season 1998–99**

These posters were also printed on the same day and the metallic orange was the same in both of them so this could be printed without cleaning the press and thus saving money. The second colour was different in both.

**Poster 4 was produced using:** Photoshop + QuarkXPress

**Prints:** Metallic orange pms 8963 + metallic green pms 8743

**Size:** A2 (42cm x 59.4cm) + A0 (84cm x 118.8cm)

**Technique:** Offset

**Poster 5 was produced using:** Photoshop + QuarkXPress

**Prints:** Metallic orange pms 8963 + metallic purple/dark blue pms 8783

**Size:** A2 (42cm x 59.4cm) + A0 (84cm x 118.8cm)

**Technique:** Offset

**Poster 6 – a special poster for a single performance held in the rehearsal studio of DRD – was produced using:** Photoshop + QuarkXPress

**Prints:** Metallic orange pms 8963 + metallic light-green pms 8683

**Size:** A2 (42cm x 59.4cm)

**Technique:** Offset

Digital Lab: Print & Electronic Design    advertising    drd

Digital Lab: Print & Electronic Design    advertising    drd

### 0.4   season 1999–2000

This is the first season that the posters were printed separately. The poster would be printed prior to the performance so that all of the information was available. Now the posters could have two different colours each time...

"Because some people at DRD thought that the colours used in the posters of the previous season were too delicate and 'precious', I used day-glo colours this time. From all of the posters I made for DRD I like this series the best. I think they are very lively and colourful and they did really well when posted outside in the streets..." says Ben Faydherbe.

### 0.5   season 2000–01

**Poster 10 (proposal) will be produced using:** Photoshop + QuarkXPress

**Prints:** Orange pms 021 + day-glo violet pms 806

Digital Lab: Print & Electronic Design  advertising  drd

10

# DRD
## DanceWorks

IN THE ROOM THE WOMEN COME AND GO TALKING OF
# MICHELANGELO
een choreochrafie van TON SIMONS

Digital Lab: Print & Electronic Design         advertising     drd

# Wout de Vringer, partner

## comments

**project credits**

| | |
|---|---|
| **Art Direction and Design** | Wout de Vringer, Ben Faydherbe |
| **Printing** | Carto-print, The Hague |

**Faydherbe/De Vringer**

2E Schuytstraat 76

2517 XH The Hague

The Netherlands

**T** +31 70 360 298

**F** +31 70 365 0219

**E-mail** ben_wout@euronet.nl

Digital Lab: Print & Electronic Design     advertising     drd

# at Faydherbe/De Vringer

"In 1997 Käthy Gosschalk, then the artistic director of De Rotterdamse Dansgroep (DRD), visited an exhibition of previous work that our studio designed for 'De Haagse Zomer', a summer festival which was held in The Hague between 1987 and 1992. She was intrigued by the striking images and bright colours and although a festival is something quite different from a dance group she wanted us to think about a 'new image' for DRD. The posters and flyers designed for the group until then weren't very outspoken and the information was difficult to read and, especially when those posters were out in the street, it was hard to see what it was they were advertising.

"The first assignment Käthy Gosschalk gave us was to design a poster for a special occasion: Ton Simons, who lives in New York and sometimes in Rotterdam, choreographed a dance especially for the celebration of the 50th anniversary of the Marshall Plan. This celebration took place in Rotterdam in 1997 and apart from this dance performance there was a whole range of different cultural events. President Clinton was invited as the special guest, representing the United States.

"This first assignment was more or less a test: Käthy wanted to see if the collaboration would be a fruitful one. She wanted to see if the poster we designed for this special occasion was in a direction she was happy with.

"Everything went well and we passed the 'test'. From then on we could start working on the new identity for the group. One of the first things we suggested was that the name of the group, 'De Rotterdamse Dansgroep', was rather long. So why not call the group 'DRD'?

"We agreed to introduce this 'new' name in phases. The first season we used both names: 'De Rotterdamse Dansgroep' fairly clear and 'DRD' as a sort of extra, a sort of typography element. Over the years that followed we pushed 'DRD' to the foreground and the full name to the background. In that way people could get used to the new name and forget the old one...

"The budget was fairly limited, so there was no money to hire a photographer to shoot images especially for the posters. However, there was an archive with photos of every performance and also a lot of photos shot during try-outs and rehearsals. Those photos were taken by Leo van Velzen and we decided to use those for the posters. The only problem was we wanted to avoid the typical dance poster approach: a big photo of one or more dancers with some typography around it. That's why we decided to just use fragments of the photos. In that way you could show the expression on the faces of the dancers rather than showing the whole dance scene.

"We decided to use strong bright colours in addition to those images and thus creating posters that were very visible when posted in the streets. They worked quite well because they were not like most posters for dance groups and we were happy that Käthy gave us that freedom.

"In 1999 Käthy left DRD and Ton Simons became the new artistic director. We had a brainstorm session about how we could head into a new direction. It was a very productive session. We agreed about working with other images, so no photos of the dancers anymore but more abstract images were going to be used. It became clear that after the first presentation both parties had different ideas about what direction we should go in with the poster design. So, unfortunately the collaboration didn't work out and we decided to give the assignment back because we didn't get the freedom we were used to while working for Käthy. All in all though it was a great project to work on and I'm still happy with the results."

Digital Lab: Print & Electronic Design  advertising  uboot.com

# project 0.6 uboot.com

Advertising agency Magic Hat's launch of an existing European brand in the UK is notable for its use of cunning marketing and guerrilla tactics in bringing the brand to the attention of its target audience of 13–20-year-olds. The advertising agency's approach may provoke initial reactions of disapproval and aversion to the manipulation of a young and ostensibly susceptible audience, done through the use of illegal activities such as flyposting and graffiti. But further investigation reveals an accomplished and inventive approach to cracking the notoriously sceptical youth market.

Uboot.com offers a web-based text messaging service that allows users to send messages from their mobile phones or computer anonymously, and to up to ten different recipients simultaneously. Thorough research into the core user group of this service, and the marketing approaches of the dominant mainstream services such as genie.com, lycos.com and breathe.com, allowed Magic Hat to position uboot.com at a tangent to their competitors. They adopted the inclusivity and sense of belonging to a community that text messaging provides, as opposed to communication as an end in itself, as the driving force behind the campaign.

The surreptitious nature of text messaging, and the control which it offers – i.e. the choice to connect without having to engage – inspired Magic Hat to imbue uboot.com with an aura of subversion and non-conformity. Abbreviations used in text messaging, such as 'no the code', 'we r many' and 'synkrnz', were utilised to create impactful headlines that spoke directly to the audience, whilst intriguing or excluding those unfamiliar with the practice. Insidious colours of green on black were employed across imagery and type, and much of the material was left unbranded.

The campaign launched with excursions into alternative marketing spaces – specifically the urban areas which the audience occupied – as opposed to established and predictable sites where the message would become neutralised and would bypass core consumers. Graffiti sloganeering (using non-permanent ink) and flyposting made use of street-level marketing in order to speak directly to the youth audience. Advertising in underground magazines reinforced the environmental campaign, and the final progression to mainstream channels where the uboot.com brand was overtly expressed, resolved the campaign.

Magic Hat's approach was the "biggest ever brand launch in the UK through experience media", and its bold decision to explicitly exclude the uninitiated was vindicated by its success in capturing a large portion of an established and intensely targeted market – uboot.com currently has over 1.8 million registered users since its launch in September 2000. The effectiveness of 'ambient media' in advertising, and its capacity for invention and surprise, can also be seen in the campaign by mother for britart.com (pp.10–19), which addresses a fundamentally different market of more mature, art-appreciating professionals, whilst employing similar subversive tactics and occupying the same non-commercial sites as uboot.com.

Digital Lab: Print & Electronic Design      advertising     uboot.com

we can c u

www.uboot.com
uboot
↓
beyond msging

Digital Lab: Print & Electronic Design          advertising          uboot.com

My shirt only cost £2.99

I regularly steal things out of people's drawers at work.

I'M NOT WEARING ANY PANTS.

I was expelled from six schools for bullying.

I'm not creative

I used to work on sex lines.

Digital Lab: Print & Electronic Design    advertising    uboot.com

### 0.1 initial developments

Embarking upon a new brief can be daunting and difficult. Unusual methods are often employed to free up the creative process and to commit thoughts to a page. The creatives at Magic Hat developed their theme for uboot.com by anonymously writing down personal secrets and confessions on scraps of paper, which were then revealed collectively to the group. This shared experience of intimacy and revelation inspired uboot.com's theme of secret societies and clandestine communications.

Digital Lab: Print & Electronic Design　　　advertising　　uboot.com

Digital Lab: Print & Electronic Design        advertising    uboot.com

# synkrnz

U SEND
U RECEIVE
U R SILENT
U BELONG
U REMAIN ANONYMOUS
U TEXT EVERYONE U WANT
AT ONCE
FROM YOUR PHONE
OR BY E-MAIL

U CAN'T IMAGINE
WHAT THIS WILL MEAN

U B LONG?

www.uboot.com
uboot ↓

# cn U hr ths

www.uboot.com
uboot ↓
beyond msging

Digital Lab: Print & Electronic Design    advertising    uboot.com

# synkrnz

U text
U email
1 message 2
10 people
at once
synkrnz

**uboot.com**
**uboot**
↓
**beyond messaging**

Digital Lab: Print & Electronic Designadvertisinguboot.com

**U text**
**U email**
**any 1**
**every 1**
**join us online**

**uboot.com**
**uboot**

**beyond messaging**

## 0.2    posters and press advertisements

Imagery and copy employed through-the-line for uboot.com is mysterious and ominous, confounding understanding rather than enhancing it. This is its goal. The placement of text abbreviations and cryptic barcodes over green-tinged, claustrophobic imagery hints at a secret society which can only be known by the initiated.

The use and repetition of eerily grinning masks which disguise the true identity of the wearer, shots of infinite reflections, and close-ups of mass-produced products, suggest an Orwellian society of ciphers and non-entities. But this has underlying appeal to the target audience which wants to belong, but also wants to be outside of mainstream society.

Digital Lab: Print & Electronic Design        advertising    uboot.com

74

Digital Lab: Print & Electronic Design        advertising    uboot.com

many

uboot.com
uboot

U text
U email
any 1
every 1
join us online

↓

beyond messaging

Digital Lab: Print & Electronic Design		advertising	uboot.com

## 0.3 ambient marketing

The adoption of unorthodox sites, and the unusual methods of utilising them, are the stock-in-trade of ambient marketing. In the example shown here, uboot.com appropriated the pavement as a canvas for a seemingly spontaneous graffitied message. The message is applied and composed in such a way that suggests it is part of a bigger picture, rather than a random and incoherent piece of vandalism.

Non-permanent paint was used, which limited the impact of the stunt to the duration of the campaign, and pre-empted accusations of irresponsibility.

## 0.4 flyposters

Flyposters are an effective medium for carrying a campaign. Inexpensive and easy to produce and distribute, they can take on a life of their own, saturating a target area without dominating it. The flyposters used in the uboot.com campaign carry no indication of the service which they are promoting, but serve the purposes of priming an audience for the forth-coming high-profile campaign, and providing discreet reminders to those that are aware of the campaign.

Digital Lab: Print & Electronic Design        advertising    uboot.com

can U hide?
www.uboot.com

no th code?
www.uboot.com

stil talkng?
www.uboot.com

who r U?
www.uboot.com

U vant it?
www.uboot.com

no th code?
www.uboot.com

U conectd?
www.uboot.com

wan 2 no?
www.uboot.com

Digital Lab: Print & Electronic Design  advertising  uboot.com

Open on close-up of Boss' eyes; computer data reflects from screen.

Stack of monitors and electrical equipment.

Cut to CCTV screen, people walking around the city.

A man with tapper and headphones who hears digitised laughing.

People moving in a strange ghost-like manner.

**Woman:** "We can't get hold of them. They're untraceable."

**Boss:** "Find them."

We cut to the tapper as he gestures to the other two to "shush".

**Boss:** "Who are they?"

CCTV camera zooms in on one of the uboot people holding a mobile phone.

Digital Lab: Print & Electronic Designadvertisinguboot.com

Close-up of mobile.
Screen reading 'U b long?'

Type and images of mobile phone screens overlayed in a graphic sequence.

CCTV image of uboot people coming together.

Van pulls up and the woman and the tapper jump out and try and surround them.

Tapper man frantically looks around and says, "we've lost them", into his walkie talkie.

Lastly we end on an even wider view of the scene with the end super (super-imposed logo over the image).

## 0.5  television campaign

'Enemies of the State' is a 30-second television advertisement which demonstrates the power of the ubooters seen from the perspective of a group who are outside the uboot community. Empowered by SMS text technology, the ubooters run rings around the pursuers and prove untraceable and unrecognisable.

The imagery here continues the theme of the press and poster advertisements. But the suggestion of an ominous and potentially threatening secret society is reversed in favour of one resisting the intrusive practices of a totalitarian establishment.

Digital Lab: Print & Electronic Design          advertising     uboot.com

# Zoë Kelly, Magic Hat

## comments

**project credits**

| | |
|---|---|
| **Director-in-Charge** | Zoë Kelly |
| **Senior Planner** | Sarah Thomas |
| **Art Director** | Gary Marjoram |
| **Copywriter** | Mike Benson |
| **Media** | Rocket |

**Magic Hat**
7 Herbrand Street
London WC1N 1EX
UK

**T** +44 (0)20 7837 4001
**F** +44 (0)20 7961 2868

www.magichat.com

"It's quite some task to successfully launch an unknown brand in a credible way to a youth target, even more so when the competition consists of long-established, strong players (with deep pockets to match) who already dominate the market.

"Much like the other mainstream players, uboot.com offers basic text messaging, accessed via the web or phone. For this largely undifferentiated product Magic Hat was to create an identity and appeal which extended far beyond its functionality to capture the imagination of the audience. This was achieved by isolating a single, motivating consumer truth, by questioning the received category norms and wisdom and by identifying an area that uboot.com could own emotionally rather than rationally.

"Ultimately, this insight was to be found in 'Cool Hunting' – our term for the group that the product held most appeal to (13–20-year-old men and women) – and it proved to be the key to the success of the campaign...

"To counteract the fragmented, unplanned nature of their lives this age group seek a sense of belonging and community to anchor them in this world. They embrace technology that links their communities and enjoy the 'complicit' nature of it to such an extent that they create their own language, their own code. They love the fact that only they can access and understand their communication with their friends.

"Magic Hat 'short-handed' this insight and called their audience 'Covert Communicators'. We recognised the opportunity for communicating the brand was not to position uboot as exclusively – or even primarily – about understanding and communicating but about belonging.

"Based on the understanding that conventional media channels have reached saturation point, Magic Hat, uboot's marketing department and Rocket (media buying and planning agency) needed to seek new communication spaces. Also faced with the challenge of appealing to an audience which is more resistant than ever to pure conventional marketing, it was necessary to find alternative means of capturing mindshare for the brand. This is particularly true for this target audience who have learnt how to bypass unwelcome communications making imaginative ways of approaching them ever more necessary.

"Targeting a core of young mobile consumers – particularly style leaders – was going to prove tricky because they consume surprisingly little mainstream media, preferring to spend their leisure time out of the home. It was decided to launch the campaign on the street, recognising that it is the best place to reach these elusive creatures. It was also the nature of street advertising that echoed the values that were being built for the brand. The style and language of the street – less overt branding, more coded messages and visual playfulness – dovetailed neatly with the brand's positioning. These learnings largely shaped the media strategy and the biggest ever brand launch in the UK through experience media was planned through three basic stages:

– Phase 1 aimed to generate groundswell, seed the brand attributes, deliver an experience and behave in a subversive manner;

– Phase 2 looked to reveal brand and product functions, and to build a broader customer base through classic media;

– Phase 3 sought to achieve brand stature, broad awareness and a stronger push for registration.

"It is interesting to review the final creative work and compare it to the original concept work submitted at the pitch – interesting also in this instance to see how close the two are. It is expected that pitch material will be reworked/revised to the point of being unrecognisable and, in some instances, will merely provide a territory as a starting point from which other ideas will spring and later be developed. It is rare that the work – strategic and creative – remains largely unchanged throughout. This is a clear sign that, once a consumer insight and an ownable space for the brand are identified, creative work that flows straight out of that understanding and dramatises it with confidence and appropriate style can engage a consumer and let them make a success out of your brand, because it has become their brand. It belongs to them."

Digital Lab: Print & Electronic Design    advertising    bioform

# project 0.7 bioform

**When asked to provide outdoor advertising campaigns for two unrelated products – Playboy TV and Charnos' Bioform bra – advertising agency Maher Bird Associates (MBA) opportunistically seized upon the similar visual subject matter to produce affinitive and innovative solutions – attracting controversy and publicity both in equal measure.**

In April 2001, Charnos were set to launch a campaign to promote their unique and assiduously developed Bioform bra, created by internationally acclaimed product designers Seymour Powell. MBA chose to utilise 3D lenticular technology – which has become a viable printing option due to its recent increased availability to production houses – to promote the product on street-level poster sites. This medium was particularly appropriate as it illustrated, in a way that standard printing processes could not recreate, Bioform's 'unique 3D support system'. It was also synonymous with technological innovation, in accordance with the engineering principles of the Bioform product. The subject for the campaign was a model wearing the Bioform bra, and she was photographed from 24 different angles whilst standing motionless for 100 seconds, in order to acquire the necessary information to construct the 3D illusion. The posters were produced at a cost of £600 each, from an initial budget of £100,000, and targeted strategic sites near retail outlets such as John Lewis and Debenhams.

A simpler, yet more ingenious approach to outdoor advertising was adopted when MBA were asked to promote Playboy TV on billboard sites. An image of the model Kathy Lloyd, wearing a white dress, was posted onto a billboard format lightbox. During the daytime, the advertisement was an unremarkable shot of the model, featuring the headline 'tune in' in black type, above the image. But as night-time approached and daylight faded, the light from the lightbox billboard would burn out any white details on the image and reveal a second layer of printing below. Subsequently, Kathy Lloyd's white dress would disappear to reveal black underwear on the lower print layer, and previously unseen type, 'turn on', on the lower layer would become visible through the upper layer's white background.

Both campaigns inevitably drew charges of sexism and accusations of the objectification of women. In the case of Charnos, Graham Kerr, chairman and creative director of MBA, insisted that the Bioform campaign was not sexist and actually empowered women. Dr Rosalind Gill, of the Institute of Gender Studies at the London School of Economics, countered, "It makes me feel depressed the way women are represented in these advertisements – they just reduce women to their cupsize." In comparison with past campaigns from competing bra manufacturers such as Gossard and Wonderbra, predominantly featuring semi-erotic black-and-white photography of models such as Eva Herzigova, and straplines such as 'Hello Boys' and 'Twin Airbags as Standard', the Bioform campaign is fairly restrained. Its visual style is soft, featuring flowing abstract shapes in shades of pink and other pastel colours, and the model's pose is functional rather than titillating. The headline proclaims, 'Statistics are not vital. Shape is.', a comparatively inoffensive statement that seems to speak directly to females rather than carrying suggestive sexual overtones aimed at males. The presence of the 3D effect, accentuating the form of the model, narrowly avoids accusations of kitsch exploitation by associating with, and demonstrating the '3D' aspect in the function and marketing of the product.

The unusual visual devices in both campaigns respond wittily and effectively to the requirements of the relative subject matter, and only the overt and unashamed effrontery of the Playboy TV campaign – which is an embodiment of the content and character of the channel – could reasonably expect criticism from those whom it offended.

Digital Lab: Print & Electronic Design    advertising    bioform

Digital Lab: Print & Electronic Design     advertising     bioform

**0.1   campaign**

MBA's audacious and inventive use of layered imagery produced this traffic-stopping billboard advertisement for Playboy TV. An underlying image of the model Kathy Lloyd becomes visible as the poster illuminates during nightfall.

Digital Lab: Print & Electronic Design    advertising    bioform

Digital Lab: Print & Electronic Design     advertising     bioform

# Creative team
## comments

**project credits**

**MBA**
Academy House
36 Poland Street
London W1F 7XX
UK

**T** +44 (0)20 7287 1718
**F** +44 (0)20 7287 0917

**E-mail** alex.simmons@mba.co.uk

Digital Lab: Print & Electronic Design  advertising   bioform

# at MBA

"This was a new product launch. The UK's Channel Four aired a documentary on the new Bioform bra called 'Designs on Your Bra', prior to the advertising campaign. This 'pre-excited' consumers and trade.

"The Bioform bra is revolutionary in its design and is a remarkable innovation. It is based on a sculptured 3D undercup support, enclosed in soft stretch Lycra Soft fibre. It gently holds and shapes the breasts, transforming the way the wearer looks. The bra ultimately gives shape to the larger-breasted woman, not in the Wonderbra way of pushing them up for all to see, but by simply holding and gently shaping. The bra took three years to design at a cost of £2 million. The creative execution and treatment was based around the fact that the product itself was 3D, so we wanted a method of showing, in 3D, the effect the bra made. It was also the first time the 3D effect had been used in poster advertising.

"3D is not only a unique approach, but it seemed the most effective way to show the primary benefit of the bra, which is the way in which it shapes a woman's bust. The innovative method of using 3D lenticular technology also reflected the brand in the light of being innovative and revolutionary.

"We placed the advertisements on backlit billboards in major cities and national press only. The campaign was launched on April 2001 and created £500,000 worth of PR for The Media Foundry agency.

"When photographing the model, the camera ran along a circular rail taking 24 photographs over two minutes. The ideal viewing position was six feet away. In this time the model could not move or breathe! The photographs were then printed on transparent sheets and stuck together to form a stack 1cm thick. The difference in angles and perspective gives the final image more depth, making it appear 3D.

'We used Tim Brett-Day as our photographer, and it was great to take a world-class photographer and combine his skills with an extremely high-class technical team."

# project 0.8  747 AM

The application of a visual identity to a non-visual product provided Dutch design agency KesselsKramer with a paradoxical and challenging brief. The Netherlands' public broadcasting station Radio 5 was a discussion station covering cultural, religious and current affairs, catering for a modest and predominantly mature audience, and was an umbrella for 21 separate broadcasting corporations. Radio 5 had acquired a new frequency, 747 AM, for the practical reasons of combining the frequency and station name, and easier accessibility (the original frequency 1008 AM was difficult to find); and for the inspiring associations that the new name offered. The requirement was to provide a unified, fresh, contemporary image, which appealed to a younger audience, and which presented a clear message as to the content and purpose of the new station.

Responding to the opportunities afforded by the 747 aspect of the name, KesselsKramer developed a theme that used aerial photography to encapsulate the aspirations and values of the renascent station, applying this campaign to national newspapers and magazines and television. The imagery selected has the cool eye of an Andreas Gursky photograph – comprehensive, impassive and sedate – with subject matter ranging from the monotony of a campsite to the drama of a tanks' graveyard. The straplines reflect the supermundane qualities of the camera's viewpoint – 'sometimes you need a little distance to get a better overview' and 'a different perspective sometimes gives a surprising view'.

The effect of the aerial viewpoint is to objectify the subject matter – the images' intrinsic beauty, drama and tragedy is rendered dispassionate and homogeneous and so the content can be considered impartially. The dislocated viewpoint of the imagery and the associations of the name with aviation, also suggest travel and the transportation of the listener to a different place, offering 'room for a detour in this age where everybody appears to be hurried'. This effectively encapsulates the values and *raison d'être* of the station – to look at the world from a bird's eye view at a distance from the issues that it covers.

KesselsKramer's campaign provides a brave and unexpected vision for the radio station. The aerial imagery, in itself not unfamiliar, is appropriated for the station, and is established as a motif which is instantly associated with 747 AM. The soundtrack for the television campaign is ambient, discordant and provokes mild unease, complementing the abstraction of the aerial imagery achieved through movement and layering. The voice-over features the calm, languorous and mysterious tones of a woman, offsetting the hard, masculine edge of the soundtrack and visuals. The logo and attendant copy of printed material is set in a clean, clear sans-serif uppercase. The combined effect of the television and press advertisements is to produce an impression of clarity, rationality and order, with a cool stance that appeals to a young, contemporary audience without appearing patronising or tacky. This justifies the decision of not adopting a highly accessible, populist approach.

It is questionable whether the association with flight can be sustained across further campaigns without becoming hackneyed and predictable, but for the short-term purpose of launching and establishing an identity and audience for the new frequency, KesselsKramer's solution effectively brands a non-visual product: "It's a place from which you can travel with your eyes closed."

Digital Lab: Print & Electronic Design    advertising    747 am

Digital Lab: Print & Electronic Design    advertising    747 am

**GEEF UW GEDACHTEN NIEUWE BESTEMMINGEN.**

Digital Lab: Print & Electronic Design        advertising        747 am

Digital Lab: Print & Electronic Design        advertising    747 am

SOMS MOET JE EEN BEETJE AFSTAND NEMEN OM EEN BETER OVERZICHT TE KRIJGEN.

Digital Lab: Print & Electronic Design     advertising     747 am

**747 AM**

**0.1 imagery**

Stock libraries provide a relatively cost-effective and time-saving solution when specific images are required quickly and conveniently. Kessels-Kramer's careful and discerning choice of stock imagery for Dutch radio station 747 AM's campaign presents a consistent and unified identity across the media of television and print.

Digital Lab: Print & Electronic Design  advertising  747 am

94

Digital Lab: Print & Electronic Design     advertising     747 am

Digital Lab: Print & Electronic Design  advertising  747 am

Digital Lab: Print & Electronic Design     advertising     747 am

Digital Lab: Print & Electronic Design  advertising  747 am

# Creative team at

## comments

**project credits**

| | |
|---|---|
| Strategy | Barbara Combee, Matthijs de Jongh |
| Copywriter | Johan Kramer |
| Art Direction | Erik Kessels, Krista Rozema |
| Production | Francine van der Lee |
| Director | Flatdogs, London |
| Editor | Jonathan Griffith |
| Design | Paul Freeth |
| Sound | Martin Green |

KesselsKramer
P.O. Box 10007
Lauriergracht 39
1016 RG Amsterdam
The Netherlands

**T** +31 20 530 1060
**F** +31 20 530 1061

www.kesselskramer.com

Digital Lab: Print & Electronic Design    advertising    747 am

# KesselsKramer

"Radio 5 is a public broadcasting station where 21 public broadcasting corporations are transmitting. Radio 5 is talk radio. It is the station which airs radio documentaries and a lot of discussions. It is the station for religion, culture and background to the news. Radio 5 used to air from 1008 AM, but on April 2001 the frequency changed to 747 AM. There was a need for a radical change because only a handful of people listened to Radio 5 and these people were ageing rapidly as well. There were a couple of other problems with Radio 5:

1. The frequency of 1008 AM is difficult to find for people (and difficult to remember)

2. For a listener, it is difficult to understand what Radio 5 stands for because of the large number of corporations broadcasting under the same banner.

"We used the frequency swap to change the home of the 21 broadcasting corporations into a broadcasting station with one clear image. For starters, a new logo and stationery were developed. And to introduce 747 AM to the public, television commercials of different lengths and spreads were developed. The campaign introduces the station as a whole but also pays attention to specific programmes.

"The brand 747 AM provides both an umbrella and a source of inspiration to these corporations. It is a starting point to give more substance and create more consistency for the station itself. And for the public 747 AM is both a practical name and it also calls up various associations. The campaign uses a lot of different advertisements and commercials to trigger people to 'join the flight'. The invitation to radio travel should at the same time attract and prepare people for a different radio experience. To arouse curiosity and open them up to really listen attentively to radio again, instead of using it as background noise… Enjoy the flight!"

# project 0.9 austereo

Austereo is one of Australia's most prominent radio networks, its stations leading the markets in most of the country's major cities, including Melbourne and Sydney. Austereo approached Australian advertising agency The Glue Society with a brief to excite media buyers and their clients about using radio to advertise dot com brands. The predominant trend had been to use outdoor posters to advertise internet-based companies. This was generating publicity, but with limited results – customers were visiting a site once, and then never returning to it. Radio was cost-effective, able to deliver a message in its entirety (as opposed to poster advertisements which can be ignored or may not be noticed), and had the advantage of repeat broadcasting which facilitated regular updating of the content. The result was that customers would return to the same site again and again, because the brand was consistently 'top-of-mind'.

The Glue Society's solution was to invite marketing directors from various successful dot com companies to endorse radio as an effective medium for promoting their businesses... on the condition however that they would be made up to appear bloodied and bruised, as though having suffered a traffic accident. The concept behind the treatment is a visual pun on the strapline 'hit by traffic' – internet parlance for customer flow to websites. The campaign appeared in advertising and trade publications as a sequence dispersed throughout the magazine. The first image to appear would feature a gently smiling model with mild abrasions, and the strapline 'hit by traffic... courtesy of Austereo'. This would then be resolved later in the same publication with a subtly different shot of the model featuring more abrasions and a broader smile. The strapline here would be 'hit again... courtesy of Austereo' and the sign-off, 'radio keeps them.coming'. The fact that this campaign appeared in specialised publications enabled The Glue Society to be more adventurous with the format, allowing them to produce two very similar advertisements within the same magazine – an extravagance nevertheless crucial to reinforcing the theme of repetition.

The attention to detail that permeated all aspects of the campaign was vital to its visual and conceptual impact, and ultimately to its success: the models chosen were enthusiastic and photogenic, and were genuine directors of the featured companies; the make-up artist, Paul Paterson, had won an Oscar for his visual effects in the film Braveheart; the photographs were by renowned fashion photographer Jez Smith; and the clothing worn by the models was styled to give a fashionable, contemporary edge. The accumulated effect is one of surreal juxtaposition; the models' prosperous appearance and expressions of evangelical serenity at odds with their alarming facial injuries. "We wanted the advertisements to break through with bloody drama and refined elegance."

The effect of the 'Hit by Traffic' campaign is very much in line with The Glue Society's approach to advertising. In their own words, they like to communicate through "one degree of disorientation".

Digital Lab: Print & Electronic Design   advertising   austereo

Digital Lab: Print & Electronic Design               advertising        austereo

102

Digital Lab: Print & Electronic Design    advertising    austereo

**MARTIN HOFFMAN
CHIEF EXECUTIVE OFFICER — SOLD.COM.AU**

HIT BY TRAFFIC 08.27, COURTESY OF AUSTEREO

Digital Lab: Print & Electronic Design     advertising     austereo

# Creative team at

### comments

| project credits | |
|---|---|
| **Marketing Director** | David Gibbs |
| **Photographer** | Jez Smith, 2C Management |
| **Make-up** | Paul Paterson |

**The Glue Society**
173 Palmer Street
East Sydney
NSW 2010
Australia

**T** +61 2 9331 0747
**F** +61 2 9331 0912

**E-mail** mail@gluesociety.com
www.GLUESOCIETY.COM

# The Glue Society

"Three creative solutions were initially tabled:

The first involved other media getting rather upset at their lack of ability to match radio's skill. Posters started crying and complaining, bus sides started getting angry, television sets started swearing etc.

"A second idea showed how radio can cause people to suddenly forget what they are doing and immediately go on-line. Images showed situations where humans had obviously dropped everything to hit various websites. Sinks overflowed with water, cars were parked in the middle of roundabouts, chip pans had got out of control etc.

"The final idea was the one we progressed with. We wanted to find various dot com marketing directors who were already successfully using radio to generate large customer bases – and ask them to endorse a positive message about radio. However, the endorsement was a rather extreme one. Each person was to appear as if they had been hit by traffic. The reason for their ridiculously bruised and battered faces would be explained with the line: 'Repeatedly hit by traffic courtesy of Austereo'. Beneath this reads the tagline: 'Radio keeps them.coming'.

"The response was extraordinary. The issue of using bloody imagery usually associated with drink-and-drive commercials for such a trivial message became a hot topic. Letters about the campaign were still running in trade publications three months after the advertisements had appeared.

"The images were printed on the front of many local and international magazines – giving our clients further exposure for their message.

"And despite the controversy, the campaign was voted Best Newspaper Campaign of the Year at the Australian Press Awards. This was somewhat ironic, given that the advertisements were promoting radio!"

Digital Lab: Print & Electronic Design    advertising    playstation 2

# project 1.0 playstation 2

The electronic games-console arena is extremely competitive, and requires a high quality of thought in its marketing output to maintain a brand's position. Since the advent of the console in the 1970s, three major players have emerged to dominate the market today – Nintendo with Gamecube, Sega with Dreamcast, and Sony with Playstation 2 (PS2) – and their preponderance tends to rotate with each respective launch of a company's new platform.

Sony's stance has consistently been to buck the trend in console marketing, and in games marketing in general. This is partly due to their lack of a recognisable, high-profile game character with which they can be identified, in comparison with Sega's Sonic the Hedgehog, and Nintendo's Mario Brothers and Donkey Kong. But neither have Sony concentrated on marketing the console, or even the concept of electronic gaming, as it is assumed that this is well established in the audience's mind. Instead, a cerebral, lateral approach is adopted to epitomise a subversive, ever-shifting Playstation 'movement'.

Recent award-winning campaigns, by advertising agency TBWA, have included the 'Mental Wealth' television advertisement – whose elfin subject, subtly distorted in post-production, many viewers believed had a genuine abnormality – and an unbranded poster campaign featuring a magnified image of red blood cells, some of which have mutated into symbols from the console's game-pad. This progressive approach to the marketing of Sony's product, which has allowed such innovative advertising to thrive, provided design agency tomato with the scope to "lead the exploration of a rule-free world" in response to a brief inviting them to "invent an underground marketing campaign for the launch of PS2". This campaign was to shadow the primary campaign.

The sketches presented on the following pages illustrate tomato's idiosyncratic free-thinking approach to a brief which allowed them to flex their conceptual muscles. From the outset they decided to forgo the prevalent approach to electronic games marketing in favour of an unorthodox, low-tech solution. An astute interpretation of the 'reality' which an electronic game occupies – i.e. it is an immersive experience conforming to its own rules which can be manipulated by, and will respond to the player – led to the concept of a 'new present' existing parallel to the 'old' present, a new 'state-time brought into being by the arrival of PS2'. The campaign consists of a variety of surreal and disorientating "snapshots of odd people who have in some way adapted their appearance". These images are superimposed with a grid of cyan circles, and are signed off with curious, cryptic statements. The overall effect is to suggest that "the world has changed but we are not quite sure how". Tomato also produced a genealogy of symbols from this new world that were grouped according to common traits (e.g. dogs and tables occupied the same group as they both have four legs); and eschewed the existing PS2 logo in favour of an ecclesiastical re-interpretation at odds with any mainstream logo.

The playful approach to the PS2 brand that tomato adopted maintained the element of surprise and perplexity that underpins the way Sony markets its consoles. The accumulation of responses of disorientation and confusion maintains the freshness and dynamism of the brand, and sustains an ongoing discourse within the broad target audience of early teens to 30-somethings, as to the true values of the Sony Playstation brand.

Digital Lab: Print & Electronic Design         advertising    playstation 2

Digital Lab: Print & Electronic Design  advertising   playstation 2

Digital Lab: Print & Electronic Design — advertising — playstation 2

## VOICES FROM THE FUTURE

WORDS ARE LIKE LYRICS
THAT TALK ABOUT THIS PERSON IF
I AM HAVE COME HERE TO TALK TO YOU
AM SLIGHTLY WEIRD WAY.
(TALK ABOUT THEIR EXPERIENCE
IN GRANDIOSE TERMS.)

---

I AM HORSE I RISE
AND DIP I AM THUNDER ACROSS YOUR LAND.
SINEW MUSCLE AND HOOF

YESTERDAY WHILE WALKING IN
THE STREET. I SAW A CAR
SKID OUT OF CONTROL.
IT APPEARED TO BE HEADING
TOWARDS. A GROUP OF CHILDREN
PEOPLE
CHATTING OUTSIDE A SHOP.
I JUMPED IN FRONT OF IT AND
STOPPED IT.

I AM A RIDDLER
HERE IS MY RIDDLE
- - - - - - - - - - -
                    DUCT
I AM THE PIPELINE, THE VESSEL
THE WINE
I AM POSEIDON SWIM WITHIN
ME

BALLAD — MY WAY

---

PS2

playstation2

---

Scatter cushion. Live
Rumble pal

PS2

Sound
light

**Digital Lab:** Print & Electronic Design — advertising — playstation 2

Digital Lab: Print & Electronic Design     advertising     playstation 2

WHICH IS THE LONGEST
A CENTIPEDE, SPAGETTI OR A SWORD
0 — 00 — 44

photos lo-tech of odd people
who have in some way adapted
their appearance
beneath their image handwritten
messages, questions riddles
Rules

A person who laughs at trees
B. FRUTIGER BOLD

Digital Lab: Print & Electronic Design    advertising    playstation 2

Digital Lab: Print & Electronic Design — advertising — playstation 2

# Michael Horsham, tomato

"The client wanted underground campaigns to run alongside more obvious mainstream ones. The brief was completely left open for us to interpret.

"Michael and I sat together and began shaping a series of documents/ideas based around our initial concepts.

"The launch of Playstation 2 creates a loop in the linear progress of time, thus pulling the past and future together to create a strange present. The future moves backwards to meet the advancing past which results in this present. The revolution is not just a political pastiche. It is a perceptual shift: a re-ordering of time, space and things. As a result we find ourselves in a new world. This world is the rule-free world. The rule-free world is inhabited by people, artefacts and ideas that are familiar but at the same time unfamiliar. This campaign is based partly upon the cataloguing and display of ideas and artefacts of this revolutionary state/time. This new campaign can be broken into two phases: dream and reality. The expansion of the idea involves a broader depiction of the new state/time brought into being by the arrival of PS2. This revolutionary state/time is of the future, is now, but also redolent of the past. The future is not the future seen in Star Trek or Brave New World. It is not a future based on clichés of technological or political progress. Instead, we know the world has changed, but we are not quite sure how."

**Silhouettes/Charts**

"A series of nine posters and press advertisements map the stuff of the revolutionary world. The posters and press advertisements are redolent of a strangely flat past world; they imply a weird future. Objects are cut out and silhouetted against a flat white background. The choice of subjects for each chart will map a genealogy of things affected by the arrival of PS2. The campaign will build from the very small (micro) to the universal (macro) which are in some way included in the changes wrought by the arrival of PS2 in the world. The genealogy is shaped by a view of the world that groups things in an odd way – objects are grouped together by common traits (i.e. dogs and tables appear in the same category because they both have four legs). This is the order of our proposed genealogy:

**1)** Basic forms: atoms; elements (periodic symbols and letters); shapes and geometrics. **2)** Flying objects: birds; bats; winged insects; planes. **3)** Four-legged things: dogs; cats; tables; chairs; cows. **4)** Vessels: cups; chalices; vases; mugs; barrels; baths. **5)** Pointed objects: swords; weapons; pins; nails; pencils; cathedrals. **6)** Flora: trees; plants; leaves; vegetables; seeds; grasses. **7)** Miscellaneous: ships; ants; chisels; cars; bananas; dinosaurs; flowers. **8)** Symbols: ecclesiastical symbols; crosses; national crosses; icons of sovereignty; rings. **9)** Crowns: objects of state; regalia; helmets and hats; hair.

"Branding is through use of the heraldic/ecclesiastical device which will appear in the lower left hand of the posters and press advertisements. The device will be rendered in Playstation blue."

# project 1.1 volkswagen

**The use of direct marketing enables a client to finely hone its target audience, and subsequently to tailor its message precisely. Direct marketing affords promotional opportunities that are not available with blanket forms of advertising such as billboards and television, and, as can be observed with BHWG Proximity's mailer campaign for the Volkswagen Passat, produces delightful and inventive results.**

Targeting fleet managers in comparison with the practice of marketing to a section of the general public, altered the nature and emphasis of the mailer campaign. Volkswagen were selling their product to a bulk buyer rather than a single-purchase customer, therefore factors such as fuel efficiency, service costs and re-sale value after a period of three years took precedence. Free reign was given to creative ideas, as the common requirement of broad appeal to a large section of an audience did not apply in this instance. As a consequence, the usual rigidity of brand guidelines was relaxed.

Volkswagen wished to remind fleet managers why the Volkswagen Passat is the leading car in its field, and asked the advertising agency to produce a mailshot using the above-the-line proposition of 'Passat – German for Detail' in a manner that was relevant to fleet managers. Taking the television advertisement's theme of the engineers' passion for the details of the car, BHWG Proximity suggested mailing a piece of magnesium – a component in magnesium alloy which is used when welding together the vehicle's components. This proved to be impractical due to the high volatility of the element – there was a risk of it exploding en route! But this error inspired the idea of using a teenager's schoolbook as the theme with which to communicate the properties of the vehicle. Budget restrictions had initially prevented the agency from developing this idea, but its strength and potential for expansion persuaded the client to lift the restraints and to pursue the idea to its fullest. The book – in concurrence with the theme of 'attention to detail' – is a litho-printed replica of an archetypal exercise book, attentive to the smallest details such as saddle stitching, ruled pages and the pencilled handwriting effect. This finely-observed method continues in the companion piece, 'My Great Big Bumper Scrap Book'.

Within these pages is a collection of newspaper and magazine articles gently parodying a young academic's studious cataloguing of inspiring information that could contribute to the enhancement of a car.

In tandem with this campaign, the advertising agency also produced a more conventional format of mailers that made witty and inventive use of materials to emphasise their particular messages. Postcards made from sandpaper and aluminium featured the straplines 'Run this under the Chairman's nose', and 'Tell the Managing Director to lose some weight', respectively referring to the durability tests that contribute to the Passat's high residual value, and the lightweight material from which the Passat is manufactured that contributes to its efficient fuel and running costs.

The critical path of an idea very often transcends the original parameters of the brief, and given the unforeseen influence of events such as we have seen here – i.e. the generation of one idea from the relinquishing of another, and the client's appreciation of the idea and flexibility with the budget – successful and award-winning results can be achieved.

210mm X 250mm SCHULHEFT 12 SEITEN

| VORRAT NUMMER | BLAU | GRÜN | ROT | GELB | ORANGE |
|---|---|---|---|---|---|
| ohne linien | 500088 | 500202 | 500225 | 500358 | – |
| liniert | 500610 | 500571 | 500584 | – | – |
| liniert 6mm mit abstand | 500519 | 500480 | 500714 | 500506 | 505628 |
| liniert 8mm mit abstand | 500532 | – | – | – | – |
| liniert 10mm | 500532 | – | – | – | – |
| liniert 15mm | – | 500545 | – | – | – |
| liniert 8mm/ohne linien abwechselnd | – | – | 509580 | – | – |
| liniert 10mm/ohne linien abwechselnd | 509593 | – | – | – | – |
| liniert 15mm/ohne linien abwechselnd | – | – | 500740 | – | – |
| niedrige hälfte 15mm liniert/obere hälfte ohne linien | – | – | – | 500701 | – |
| niedrige hälfte 8mm liniert/obere hälfte ohne linien | – | – | 500688 | – | – |
| 5mm kariert | 500623 | 500636 | 500649 | 500662 | – |
| 7mm kariert | 500779 | – | 500792 | – | – |
| 10mm kariert | 500675 | – | 500727 | – | – |

Passat

Digital Lab: Print & Electronic Design  advertising  volkswagen

### 0.1 gimmicks – materials

The adventurous use of materials in BHWG Proximity's direct marketing campaign for the Volkswagen Passat contributes to the concise and witty delivery of specific messages.

'Tell the Managing Director to lose some weight' is an A5-sized mailer printed onto the lightweight aluminium from which the car is constructed.

'Run this under the Chairman's nose' is printed onto sandpaper – a sample of the material used in the vehicle's durability tests.

'A solid argument' is an information pack designed to look like a riveted piece of metal. This doesn't reflect the qualities of the vehicle, but continues the theme of the use of unusual materials, and gives consistency to the overall campaign.

'Get on the Financial Director's wick' is another pun that reflects the material nature of the mailer. In this instance the information is carried on an insert wrapped around a candle.

These mailers provide a physical, tactile dimension that television and print campaigns can't. This enhances their ability to capture and hold attention. And rather than being discarded, as is the fate of most mailers, the recipient may wish to keep these items – which is another advantage of this extraordinary approach.

Digital Lab: Print & Electronic Design            advertising    volkswagen

**Get on the Financial Director's wick.**

When you light this candle you'll be able to demonstrate why all Volkswagens have long anti-perforation warranties.

Because we flood all the body cavities with hot wax.

Just one of the reasons why our residual values are so high. And why more and more businesses are seeing the sense of a Volkswagen fleet.

To find out more call 0800 38 989 38, or visit our web site at www.volkswagen-fleet.co.uk

**Engineered to save you money**

Digital Lab: Print & Electronic Design        advertising        volkswagen

## 0.2 gimmicks – homage

This beautifully lithographed recreation of a schoolchild's exercise book provides the mailer with a precious and valuable quality. Details such as the fine blue lines of the notepaper add an authentic touch to the piece. And liberties become possible, such as the handwritten rendering of the Volkswagen Passat marque in the bottom right-hand corner of the exercise book's back cover.

Added touches, such as the clear plastic zippered sleeve which contains the mailer, contribute to the success of the idea.

Digital Lab: Print & Electronic Design  advertising  volkswagen

Digital Lab: Print & Electronic Design		advertising    volkswagen

122

Digital Lab: Print & Electronic Design    advertising    volkswagen

**Task** — Take 2 metals. Comment on their physical properties, their weight and appearance. Then using a domestic hammer subject them to extreme stress. Write down anything you notice about their strength and how much damage they sustain.

**Substance** — Magnesium Alloy

**Physical properties** — Greyish metal, lighter even than aluminium

*[Sketch: a shaded square of metal with a small dent, labelled "I hit it here (very hard)", next to a hammer labelled "Hammer"]*

**Test Results** — I hit a strip of the metal very hard with the hammer but I hardly marked it. This is not because I am weak but it had the strength of steel.

**My Comments** — Could it make gear boxes lighter?

Digital Lab: Print & Electronic Design    advertising    volkswagen

**0.3    gimmicks – homage**

Again lithographed, this imitation scrapbook – a companion piece to the exercise book – features a variety of painstakingly assembled clippings and instant photographs. The accumulation of observation and detail contributes to a delightful and cherishable object which is more likely to be filed for future reference than confined to the dustbin.

Digital Lab: Print & Electronic Design   advertising   volkswagen

Wonder if something like this could work for cars?

Heidi soaked me with a high pressure water pistol yesterday but its pump action gave me an idea for a diesel engine. If fuel was injected via a similar pump on each cylinder, the pressure would give the engines loads more power.

I need to find out more about pyrotechnics. Perhaps a small charge could make a seatbelt react even faster!

The Passat. I reckon Dad must have been sneaking a look at my scrapbook.

Digital Lab: Print & Electronic Design     advertising    volkswagen

# Steve Edwards, art director

## comments

**project credits**

| | |
|---|---|
| **Art Direction** | Steve Edwards |
| **Copywriter** | Chris Barraclough |
| **Account Director** | Heidi Cartledge |
| **Group Account Director** | David Parslow |

**BHWG Proximity**
191 Old Marylebone Road
London NW1 5DW
UK

**T** +44 (0)20 7298 1000
**F** +44 (0)20 7298 1001

www.bhwgproximity.com

Digital Lab: Print & Electronic Design　　　　　advertising　　volkswagen

# at BHWG Proximity

"Addressed to company fleet managers, this mailing was designed to remind them of why the Volkswagen Passat is the leader in its class. We were asked to use the above-the-line proposition of 'Passat – German for Detail'. The television advertisements showed the passion that Volkswagen engineers have for their car – the same pyrotechnic mechanism used on jet aircraft ejector seats helps the seatbelts react faster, the smooth open/shut mechanics of a CD player is used for the coffee-cup holder and bulletproof glass as used by the President of America is in the Passat's headlamps.

"The issue we faced was to use this above-the-line idea but to make it relevant to a fleet manager. Fleet managers do not drive the cars themselves and are more interested in the cost – both the initial price and what it will cost over the period of use, i.e. fuel efficiency, value after three years, service costs etc. Also, unlike the television advertisements we wanted to make the case by showing lots of different ways in which Volkswagen had engineered the Passat.

"One of the early ideas was to send a piece of magnesium through the post. Magnesium alloy is used to weld components together as it is both very light and very strong. This was until we realised that magnesium is a semi-volatile element and could possibly explode in the post! It was while we were thinking about this that the idea of a teenager's schoolbook came to fruition. It is one of the few occasions when any thought is given to the properties of metals.

"The brief did not change much except that when the client saw the creative idea he felt that much more could be done. We initially had a schoolboy poster in the style of a Dorling Kindersley educational book. This is all that the budget could stretch to. The client asked us to re-address this piece and not to worry about keeping within budget. With the budget restraint lifted we were able to produce the scrapbook. You'll notice that the Dorling Kindersley idea remained as one of the cut-outs. The fact about offshore rust protection as used on the Passat was found whilst reading through one of their books.

"This piece has won many creative awards and has been accepted into the 2001 D&AD Annual for Direct Mail. Some fleet managers and marketing directors of other car marques have said, 'it is the best piece of direct mail the industry has ever produced', but they might be exaggerating. It has won the Best of Show in the recent Smart Awards. These awards applaud the print industry's contribution to direct marketing. It is the superb attention to detail in the print, paper stocks, handwriting etc. that make our piece so authentic."

Digital Lab: Print & Electronic Design — advertising — cat denim

# project 1.2 CAT Denim

**Caterpillar is a long-established brand in the construction industry, originally synonymous with earth-movers, construction and its distinctive triangular yellow and black logo, sometimes featuring the abbreviated brand name 'CAT'. The company has also developed a range of work clothes specifically for the use of its construction workers, ranging from hard-wearing boots to denim jackets and jeans. These products have been caught up in the zeitgeist for unconventional sources of fashion – often culled from industrial workwear, and including the likes of Carhartt and Doctor Marten – have become accepted as a mainstream fashion brand.**

Magic Hat were approached to help Caterpillar launch their denim range globally in a series of print advertisements. By comparing the desired values of the target group of 18–25-year-olds, and Caterpillar's existing values of enablement and realising dreams, common ground was identified in the 'progress of self'. Caterpillar's construction heritage of renewal of the landscape, of clearing away to allow rebuilding, was an effective metaphor for the spirit of the target audience – a group of people optimistically emerging into adulthood to build new lives for themselves. As the Caterpillar brand was already established in the minds of the target group, a relationship needed to be forged between the brand and the denim product.

Caterpillar's association with the formation of western urban landscapes inspired Magic Hat to build this link into the campaign imagery. Gritty, illustrated pieces and photomontages were created that portray the denim product as an intrinsic element in the cityscape. While the urban scenery is rendered in rough, simple lines, the product and the distinctive yellow brand tag on some denim lines appears as a tangible, predominant marker. The brand tag is echoed within the landscape in the form of yellow street lamps, taxi-roof-signs and vehicle indicators, which respectively suggest illumination, accessibility and direction – key factors in the concerns of the target group.

This approach to the product is notable in that the actual product is rarely shown, and when it is, for example in the photomontage pieces, it is obscured. This is because the brand is the focus of the campaign, not the product. Similarly, the cult of the model is renounced in favour of the cult of the brand – the illustrations portray only the backs of people, thus the use of models is sparing and understated. Also, the use of illustration as a medium, and the minimal use of copy and type, facilitates the advertisement being accepted in both eastern and western cultures. While the content of the imagery is essentially western, its styling is reminiscent of the comic-book art which is pervasive in the east.

Caterpillar Denim does not attempt to compete with higher profile brands such as Lee, Levi's or Evisu, or to pitch its campaign at the conceptual level of campaigns such as Levi's' 'Twist' or 'Flat Eric', or Lee's 'Buddy Lee'. Magic Hat's campaign firmly establishes Caterpillar Denim within familiar territory, reinforcing the (sub)brand, consolidating an understanding with its target audience and inviting them to participate in the building of its values.

Digital Lab: Print & Electronic Design      advertising      cat denim

**Digital Lab:** Print & Electronic Design  advertising   cat denim

Digital Lab: Print & Electronic Design    advertising    cat denim

Digital Lab: Print & Electronic Design  advertising   cat denim

### 0.1 photomontage

To create this press advertisement for Caterpillar Denim, a selection of photographs are scanned and then manipulated in Adobe Photoshop. The required elements of each shot are digitally 'cut out' and pasted into separate layers. Noise filters and colour-blending tools are used to achieve the desired level of 'stress' and contrast. The yellow motifs are then added and subtly adjusted to retain some of the texture of the underlying layer.

Digital Lab: Print & Electronic Design          advertising     cat denim

Digital Lab: Print & Electronic Design  advertising  cat denim

**Denim**

134

Digital Lab: Print & Electronic Design | advertising | cat denim

### 0.2 illustration

Here we can see that the source image for this digital illustration is the subject used in a photomontage piece. The selected image is simply traced in a vector graphics application, such as Adobe Illustrator or Macromedia Freehand, and graduation properties are applied to achieve the rich colour quality. Layers are used to position the elements appropriately.

Digital Lab: Print & Electronic Design  advertising   cat denim

# Zoë Kelly, Magic Hat

## comments

**project credits**

| | |
|---|---|
| **Writer** | Sarah Thomas |
| **Director-in-Charge** | Zoë Kelly |
| **Head of Art** | Rob Clarke |
| **Art Director** | Ben Crook |
| **Designer** | Gary Marjoram |
| **Illustrator** | Nick Reddyhoff |

**Magic Hat**
7 Herbrand Street
London WC1N 1EX
UK

**T** +44 (0)20 7837 4001
**F** +44 (0)20 7961 2868

www.magichat.com

"For Magic Hat, Caterpillar was an interesting brand. It has a strong core of excellence and fame in the construction world but has a portfolio of products that range from solar turbines to t-shirts. And denim. Quite a 'stretch' by anyone's standards but Caterpillar has managed it by remaining dedicated to a core of values, such as innovation, quality and dependability, which drives the brand in all it does.

"Magic Hat's job was to find the heart of the brand, the soul of Caterpillar that would bring the brand to life for consumers. Central to this was Caterpillar's unique focus, not on product features, but on functionality, i.e. what the product does for its user. As previously mentioned, Caterpillar's heritage is construction, more specifically earth-movers. These machines come at the start of the building process and basically clear away the old to make the new possible. From this simple utilitarian act comes Caterpillar's unique philosophy of enablement and making dreams possible.

"So, what does that mean when you have denim to sell?

"We started at the core of the brand and compared it to core values of the target audience (18–25 year olds). We found common ground in one key consumer value, which kept appearing time and time again in our youth research programmes; namely, progress of self.

"This age is notable for its search for identity and independence. They are emerging fully into the adult world and are keen to start gaining ground. They are optimistic in their own ways; more outwardly in the east, more cautiously in the west, but they are all future focused. They are in flux but are ultimately self-defining and look to brands that symbolise success in that process.

"So why does all this matter?

"The target audience knew about Caterpillar, both its heritage and its products, but this was a passive, detached relationship. We needed it to be an active relationship, with the audience accepting and identifying the brand as part of their repertoire in building their new selves.

"We needed to move Caterpillar from the building site to the wardrobe.

"So we know that the audience and the brand share similar values. The denim range was created with the brand's value at its heart: innovation, quality and dependability – all good jean values. Add this to the fact that these were jeans from a construction machine company and that those values are placed in a new, more powerful context. The jeans are part of a heritage that created the American landscape – the definitive urban landscape. Now we have something to hold. We have our 'territory'. We just had to fix it to the denim sub-brand language.

"The creative work that sprung from this casts the denim product, with its distinctive 'yellow tag', as a signpost in the urban framework around it. The yellow tag takes iconic status, the only solid block in a world as roughly drawn as scaffolding. The wearer stands amongst the other lines, playing (simultaneously, and distinctly at the same time) with the cityscape that surrounds them. The cut-off angles and jagged viewpoints all heighten the sense of immediacy and casual chance view. The iconic logo is caught, as if in an urban spider's web.

"The decision to use illustration, rather than photography, was guided by a desire to own a distinctive, iconic style born from the roots of the brand. The physical method employed to create the layouts involved literally building the image piece by piece, brick by brick, layer by layer, contemporising and reflecting Caterpillar's construction heritage."

# project 1.3 guinness

The 'Good Things Come to Those Who Wait' campaign has been hailed as one of the most successful campaigns in the history of British television advertising. Produced by Abbott Mead Vickers · BBDO, whom the client appointed to inspire new direction for the brand following 12 years with Ogilvy & Mather, 'Dream Club' is the final advertisement in a series of four. Witty, wise and unsettling, it maintains the approach of strong storyline, superior direction and extraordinary concept, that has underpinned the previous three films, 'Swimblack', 'Bet on Black' and 'Surfer'.

The central figure is a member of the 'Dream Club', and is appointed to discover the meaning of life using his gift of acquiring answers in his dreams. After ordering a pint of Guinness, he falls asleep and awakes to find himself in a surreal dreamscape. The narrative is immediately cast into confusion when a squirrel awakes from a similar situation to the protagonist, announces "I've just had the weirdest dream!", and gulps down a pint of Guinness. We are then witness to an uproarious mob of people scrambling one on top of the other to peer into a hole high on an enormous canvas of skins, which is stretched across the breadth of the street. The hero conquers this human mountain and peers into the hole, to discover that he is looking at himself sleeping. The scene cuts to a shot of him laughing in his sleep, as a crowd of hundreds awaits his revelation.

The use of the dream as a theme for an advertisement allows director Jonathan Glazer to be adventurous in his cinematic approach, and to depart from the expected mores of television advertising. The assumption of a conventional, linear narrative is confounded by the insertion of the squirrel episode, which casts a degree of doubt and disorientation across the entire advertisement; whimsical fantasies that defy logic punctuate the scenes – a pack of dogs leaping and laughing, a horse reminiscent of those in the acclaimed 'Surfer' rolling hysterically on its back. The subtle resolution of the story leaves the viewer in doubt as to whether the advertisement has truly been interpreted correctly. This accumulation of visual delights and directorial conceits demands repeated viewing and close scrutiny, ensuring that the product will be imprinted on the memory of the viewer.

In the fiercely competitive field of alcohol advertising, which includes such heavyweight brands as Carling Black Label, Carlsberg and Holsten Pils, Guinness consistently produces memorable and popular advertisements which find a place in the hearts of its audience – 'Surfer' was voted the best television advertisement of all time by viewers of the UK's Channel Four. The success of 'Dream Club' and the others in the series can be found in the unconventional approach to the product that they are marketing. The facile adoption of Irish kudos is emphatically rejected in favour of an inclusive, cosmopolitan approach which also ensures the success of the campaign in other countries – 'Swimblack', 'Bet on Black', 'Surfer' and 'Dream Club' are set in Italy, Cuba, Hawaii and Hungary respectively. The central characters – 'brand heroes' – are culled from these localities and embody the values of integrity, vitality and inner strength. The 'blockbuster' approach to the campaign is a rare example of the budget supporting the concept rather than driving it, yielding results that are unpretentious and poetic. The efficacy of Guinness' liberal approach to its product and marketing is supported by statistics, with sales increasing substantially since the launch of the campaign.

Digital Lab: Print & Electronic Design    advertising    guinness

Digital Lab: Print & Electronic Design         advertising     guinness

140

Digital Lab: Print & Electronic Design    advertising    guinness

Digital Lab: Print & Electronic Design    advertising    guinness

Digital Lab: Print & Electronic Design          advertising     guinness

Digital Lab: Print & Electronic Design  advertising   guinness

144

Digital Lab: Print & Electronic Design     advertising     guinness

**0.1 unused footage**

In order to maintain a balance between narrative and visual, much material was omitted. Here we see a sample of content which was consigned to the cutting-room floor. The protagonist finds himself pursued by an old woman in a Soviet army uniform, who constantly beckons to him; the film cuts to a scene where he is running against the flow of the crowd in a street, only for the old woman to reappear beside him. With this disturbing and possibly familiar dream content, this sequence was deemed inappropriate to the light-hearted tone of the advertisement.

Digital Lab: Print & Electronic Design

advertising    guinness

# Creative team at Abbott Mead

## comments

**project credits**

| | |
|---|---|
| Agency | Abbott Mead Vickers • BBDO |
| Creative Director | Walter Campbell |
| TV Producer | Yvonne Chalkley |
| Director | Jonathan Glazer |
| Producer | Nick Morris |
| Art Director | Chris Oddy |
| SFX Technician | Peter Szilágyi |
| Stylist | Andrea Flesch |
| Post-production | Computer Film Company |
| Visual Effects Producer | Fiona Chilton |
| Animation Supervisor | Sally Goldberg |
| Lead Animator | Rachel Ward |
| Creature Set–up | Penny Leyton |
| Computer Graphics Artist | Rangi Sutton, Justin Martin, Joel Meire |
| Fur Design | Chris Monks |
| Modelling | Louis Dunlevy |
| Sound Design | Peter Raeburn, Johnnie Burn |
| Editor | Sam Sneade |

**Abbott Mead Vickers • BBDO**
151 Marylebone Road
London NW1 5QR
UK

**T** +44 (020) 7616 3500
**F** +44 (020) 7616 3600

**E-mail** amvbbdo@amvbbdo.co.uk

# Vickers · BBDO

"The champion of the 'Dream Club' is going for an amazing dream to uncover the meaning of life. He orders a Guinness as he drifts off.

"His dream unfolds, he sees a squirrel which is shocked at seeing him. The squirrel then wakes and announces it's just had a weird dream.

"We now see our champion in a street in Dreamland trying to get back on course for his big dream.

"He rouses himself in the dream and goes after the secret of life. We see various strange things, a laughing horse, people climbing over each other while laughing ecstatically, dogs that jump and bark as if caught up in the atmosphere of the moment.

"Finally he reaches the tiny hole in the massive canvas people have been climbing up. He looks through and sees himself asleep in the bar. This makes him laugh but it's the sleeping figure we see laughing, because he's actually laughing in his sleep.

"Meanwhile we see that other members of the 'Dream Club' have gathered to see what the champion has been dreaming. They wait patiently while he laughs at the image of himself laughing.

"A title appears: 'GOOD THINGS COME TO THOSE WHO WAIT'.

"Computer Film Company (CFC) worked on the various special effects that appear throughout the advertisement. The squirrels are all 3D computer-generated, but the environments are real – the bar in which they appear is an actual bar in Budapest. The computer package used to render and composite the squirrels is MAYA and the film's black-and-white tones were balanced on the computer package Inferno.

"In order to create a realistic representation of the fur, particularly to recreate the play of light and shadow, a new M-tool was created. M-Tools are similar to filters and can be customised by the program operator.

"The director, Jonathan Glazer, wanted each squirrel to be realistic and rough, like a bunch of guys in a bar. He insisted on paring down the squirrels' movements to the bare minimum, and that they should be absolutely lifelike and not 'cartoony', although human characteristics were incorporated to create convincing movement. In order to research their anatomies, three squirrels from an animal rescue centre were brought in to be studied.

"The horse and dogs were added in post-production – the horse could only be encouraged to roll in sand. The stuntman who falls from the tower of people was supported by a rig, which was removed in post-production."

# project 1.4 rizla

The vast club- and music-orientated subculture that epitomises contemporary youth is a highly coveted and much sought-after market for many of today's fashion brands. Established sportswear manufacturers such as Nike and Adidas market themselves aggressively and extravagantly to maintain their prevailing profile and territorial dominance in this area, whilst the less predominant, more disparate array of associated youth brands access this market through niche concerns such as skateboarding apparel and urban-wear (Carhartt, FatFace, Solomon), and the received credibility and understated cool of premium-priced fashion-wear (Ted Baker, Diesel, fcuk). The presence in this marketplace of a brand that can be associated with a user base as diverse and eclectic as "bikers, anglers and whippet trainers", to students and club-going young professionals, is as unexpected as it is unprecedented, and is a testament to the bold and open-minded approach of the manufacturer to the marketing potential of its product.

Rizla approached the design agency Cake with a brief to promote the credentials of their "low profile, low value" product – a seemingly thankless task with a product as mundane and utilitarian as a book of rolling papers. Fortunately, the unassuming nature of the product belied a rich substrate of social references and associations that Cake were able to utilise. Rizla had been a low-key but ubiquitous brand within modern club culture since the latter's birth in the 1990s, and was, by default, the paper of choice for many users of tobacco-based products. This provided Rizla with familiarity and credibility, and was the fuel that allowed Cake to dynamically reposition the brand. They approached it as though it were a music band and mobilised their experience in this area to promote it in a similar way.

By building Rizla's profile within the culture that it pervaded – i.e. festivals, clubs etc. – Cake were able to manipulate the brand audaciously and radically, with little fear of alienating its user base. The creation of the Rizla Café, now a "regular and much-loved feature of the festival circuit", provided the brand with an environment within which it could express its new-found flamboyance – from branded clothing and innovative 'rolling jackets' featuring transparent all-weather rolling pouches, to furniture in the shape of the 'cross' logo, and sofas replicating rolling machines. Rizla also positioned itself alongside DJ culture, playing host in the Rizla Café tent to names such as David Holmes, Basement Jaxx and Groove Armada. This shrewd association provided synonymy with the brand and contemporary music of the moment, further diversifying Rizla's permeations within its target scene.

Rizla's eschewal of the rigid and often restrictive conventions of branding – e.g. the absolute association of brand name and mark within a given space – gave the agency freedom to play with the logotype, replacing the name with witty substitutes such as 'Phoenix' (i.e. from the flames) when sold at the 1997 festival of the same name; and 'Rizbee' for the branded frisbee merchandise. Yet the '+' logo is a constant throughout the entire re-positioning exercise, providing a strong and consistent icon that is as recognisable in isolation, or in incongruity, as the Nike 'swoosh'.

With the increasing possibility of the prohibition of all forms of tobacco-related advertising, Rizla's dynamic and progressive shift into the realms of merchandising and environmental branding have provided it with substance and a grounding from which to continue to innovate with impunity from the strictures of the potential legislation.

Digital Lab: Print & Electronic Design		advertising	rizla

Rizla Lounge Neon from 2000 – Tom Oldham

Digital Lab: Print & Electronic Design | advertising | rizla

Rizla Café 1999 – Mike Stone

Rizla Lounge 2000 – Mike Stone

150

Digital Lab: Print & Electronic Design					advertising		rizla

FINEST QUALITY GUMMED PAPERS

Wobble, Rizla installation 1997

Rizla Café 1999 – Mike Stone

Rizla coffee cup – Steve Lazarides

### 0.1 environmental branding

The creation of an environment within which to promote and develop the Rizla product is shrewd in pre-empting possible legislation banning the advertising of all tobacco-related products. Establishing such an environment provides a market for the product and assures the survival of the brand.

### 0.2 ambient marketing

The café environment encourages the creation of such entertaining pieces as the rolling-machine sofa and the paper-book tables. These sort of marketing conceits can only work within a favourable context, and would be irrelevant outside the Rizla Café.

Whimsical touches such as the logo-shaped chocolate topping on cups of cappuccino add to the friendly and considered ambience.

Digital Lab: Print & Electronic Design    advertising    rizla

Phoenix Rizlas – Adrian Myers

Glorious Izzlas – Adrian Myers

Rizla frisbee – Adrian Myers

Rizla torch and lanyard – Adrian Myers

0.3   accessories and limited editions   ↑

The utilisation of accessories to carry the brand provides a constant reminder of the product. Adventurous and humourous adaptations of the brand name, such as 'Rizbee' as featured on the branded frisbee, and the reference to the Phoenix festival, enhance the retention of the brand name in the memory of the audience.

Digital Lab: Print & Electronic Design          advertising     rizla

Rizla girls vests – Eddie Otchere

Rizla factory workshirt – Eddie Otchere

Rizla Lounge CD, 2000 – Adrian Myers

First Rizla brochure – Eddie Otchere/Adrian Myers

Second Rizla brochure – Helen Marsden/Adrian Myers

## 0.4    apparel    ↑

The incorporation of the brand or product name into clothing assures the longevity of its exposure. Whereas dedicated clothing producers are able to employ this technique as a matter of course, it is unusual for a non-fashion-wear company to attempt this. But by taking advantage of the nature of the product, and the visual strength of the logo, Rizla were able to produce a jacket containing a novel and useful transparent rolling pouch (overleaf), and items such as rings and keyrings in the shape of the '+' logo.

Digital Lab: Print & Electronic Design    advertising    rizla

Digital Lab: Print & Electronic Design        advertising    rizla

Rizla rolling jacket – Adrian Myers

Digital Lab: Print & Electronic Design       advertising    rizla

# Creative team at Cake

## comments

**project credits**

**Cake**
Cake Group Limited
The Mission Hall
9–11 North End Road
London W14
UK

**T** +44 (0)20 7471 6666

**E-mail** mail@cakemedia.com
www.cakegroup.com

Rizla Ware clothing and jewellery, for men and women. Catalogue available on 07000 749 527 or www.rizla.com

Rizla Ware advertisements – photography Eddie Otchere

"Rizla's a funny one. Used by bikers, anglers and whippet trainers alike. Plus they are low value (currently 22 pence), nor is rolling a fag exactly glamourous. And yet, there's something kind of rock and roll about it…

"So when Cake picked up the brief from Rizla; 'get this low profile, low value, small booklet of papers some status in the wider world', we jumped at the chance.

"Our solution came straight out of that latent 'rock and roll-ness' and our experience in the music business. All Rizla activity would fall under a central theme – 'Think Like a Brand, Act Like a Band'.

"So the thinking went, 'let's imagine how a new band would behave and replicate a path of success over a three-year period.

"What does a band do? A band starts appearing in clubs, so we appeared in clubs. Not the superclubs with cheesy banners or dollies in baseball caps, but at the right entry level with Scaramanga, Basement Jaxx, Bugged Out and Wobble. In 1996 they were all virtually unknown but today two of them have become household names!

"A band also appears at festivals, small scale at first but then gets bigger and bigger. This thought became the Rizla Café, now a regular and much-loved feature of the festival circuit. A comfortable, relaxed atmosphere with top DJs and quality food and drink. Good for Rizla, fantastic for bedraggled festival-goers. Between 1998, 1999 and 2000, the café gradually got bigger and better. It's a great place to hang out, whoever you are.

"Every band has a logo, be it the Stones' 'mouth and lips' or Wu-Tang's crescent. Rizla has a great logo in the cross. It appeared in the café as furniture, gobos and there was even something in the coffee.

"The cross helps in another crucial area of a band's marketing (and our brand's marketing): merchandise. Cake created a unique range of merchandise with the cross as the hero image. The first shoot for the merchandise took place at the Rizla factory in Wales, merging the brand's incredible heritage with a contemporary feel.

"The merchandise included t-shirts, the actual factory shirts, jewellery designed by Johnny Rocket and even Rizla underwear. This also allows us to advertise Rizla in a new way – for example in a 'create your own scene' brochure mirroring cereal packs we loved as kids. The great thing about merchandise is that as well as getting your name out there it can also bring in some cash.

"The other piece of merchandise that is now near legendary is the Rizla Rolling Jacket. A tempered nudge to Nike with their 'Function over Fashion' claim. A transparent pouch allows the roller to see what he or she is doing – whatever the weather. Additionally, there is a handy Velcro strip on the pocket to remove any surplus tobacco.

"Merchandise you wear, gadgets you can't do without. Be it Rizbees or Frizlaz for gigs or a torch for the late night swagger back to the tent in the Green Fields carefully avoiding those tent ropes…

"OK. Now we're rocking, time to put out our first CD. Laid back tunes, deep from the heart of the Rizla Lounge. Mmmm smooth. Now let's kick back and watch the royalties roll in…"

## acknowledgments

Advertising is often a secretive and closely guarded practice, with the public only seeing the final result, be it a poster, a television advertisement or a campaign. For this reason we would like to thank all the people who have made it possible to show some of the workings behind this fascinating cultural and creative industry. Without the help, time and encouragement of these individuals, the collation of this book would not have been possible.

With special thanks to Matt Lumby for all his help with the collation and additional writing within the book.

With thanks to: Joe Kerr at the Royal College of Art, Christian Mark Rodland, Siobhan Allen at The Glue Society, Julie Cook at Cake, Zoë Kelly at Magic Hat, Tera Small at Fallon Minneapolis, Dave Bell and Lineke at KesselsKramer, Chantel Webber, Odile Garner at MBA and Wout de Vringer.

An additional thank you to Xavier Young for all his help in photographing the submissions in this book.

We would like to say special thanks in particular to our dedicated editor Natalia Price-Cabrera for all her help in the development of this book.

Gavin Ambrose and Chris Kelly at Mono